ARTIST'S JOURNAL WORKSHOP

creating your life in words and pictures

Cathy Johnson

NORTH LIGHT BOOKS
CINCINNATI, OHIO
www.artistsnetwork.com

TABLE OF CONTENTS

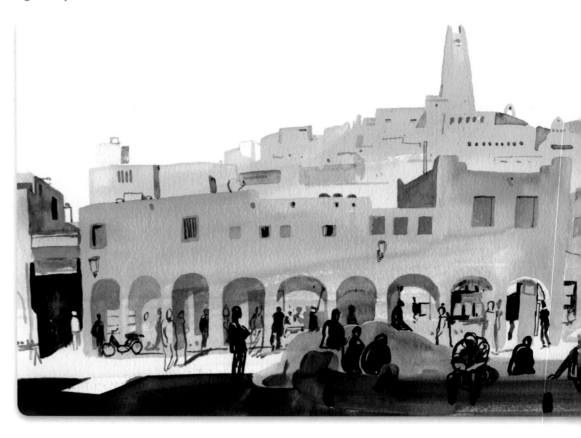

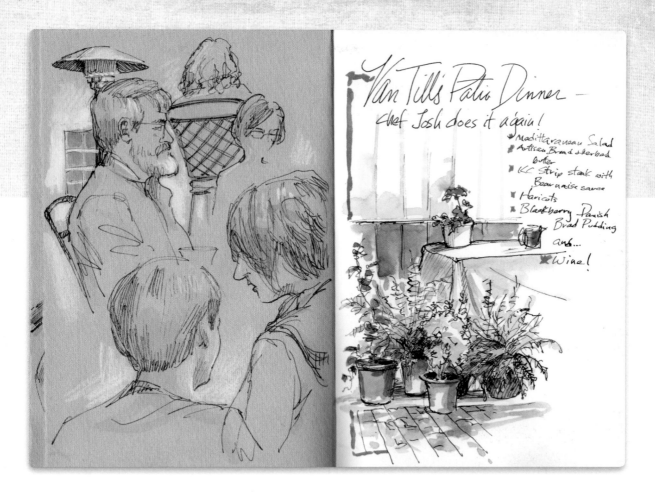

Van Till's Patio Dinner —
chef Josh does it again!

★ Meditarranean Salad
★ Artisan Bread & herbed butter
★ KC Strip steak with Bearnaise sauce
★ Haricots
★ Blackberry Danish Bread Pudding

and...
★ Wine!

Westport Road & Pennsylvania Ave. — I've spent a lot of time there... AUG 19 2009

Kelly's Westport Inn

Journal Artists
Top: Cathy Johnson
Bottom left: Enrique Flores
Bottom right: Cathy Johnson

INTRODUCTION

I'll admit, I prefer the term "artist's journal" rather than "art journal" to describe what we're about here—and there's a reason for that. There are many books and classes on making an art journal. For instance, an altered book in which the pages are small works of art in themselves, full of collage, calligraphy, stamps and scraps of this and that is an art journal. So is a book with a configuration that is almost like origami or a journal with a cover or other details that makes the book itself art. Some books are decorated with tassels and beads; some have a steampunk look, with gears and bits of metal. These are often meant to be displayed in a gallery or museum and may be sold to a collector.

Instead, we're going to explore what it means to keep an artist's journal, a personal journal kept by the creative person that is you. You are an artist and a fully rounded, creative human being with plans, questions, answers, needs and goals, both ordinary and sublime. You explore, you respond, you worry, you delight in the moment—and your fingers itch to capture that moment. Your curiosity is piqued and you search for your own answers, making notes and sketches as you go. You celebrate a milestone or the everyday occurrence. You run out of tea or eggs, or need to remember a phone number or what happened at that meeting you attended. Into the journal it goes! Your journal can be a place to express all of that, to capture the moments of your life. (It can also be an "art journal," if that's what you want—it's your decision.)

People sometimes tell me their lives are too boring or uneventful to journal; I'm not buying it. They say there's

nothing to draw that's not mundane. But seeing and capturing such things in the pages of a journal rescues them from the mundane. By giving attention and respect to small things, you raise them to a new level. Journalists find beauty everywhere.

There are many forms of inspiration behind my own journal keeping, beginning with the wonderful illustrated books I've loved as both a child and a woman—storybooks, fairy tales, natural histories, field guides, travel journals and more. It occurs to me that my own journals are a natural progression, a meandering line trailing from those books that have influenced me throughout my life to the image I sketch there today.

Thirty years ago Morton Kelsey's books on spiritual journaling inspired me. In the late 1980s, my friend Hannah Hinchman wrote *A Life in Hand: Creating the Illuminated Journal*, my all-time favorite book on the subject. It changed the way I kept my journals and helped me to see that I could integrate everything under one cover—planning sketches, practice, nature observations, grocery lists, everything, in any medium I chose.

Later, Danny Gregory's books, *Everyday Matters* and *The Creative License*, helped thousands of people realize their everyday lives could be beautiful and worthy of notice, no matter what they were dealing with at the time. He continues to be an inspiration.

Journal keeping has been a life-changing experience for me, one that has continued for more than forty years.

This book will show you how to keep your own artist's journal. As you celebrate the moments of your life, you'll discover your own way of capturing them on paper, whether you choose to do simple gesture sketches in less than thirty seconds or to design a complex page with

Rome as seen by Danny Gregory

borders, textures, layers or text. You'll explore ways to express what you feel in the way that works best for you.

There are no rules. There's no right or wrong way. It's up to you to let your journal evolve into what you, personally, want (or need!) for it to be. This book provides a map, as it were, with signposts along the way, but you choose your destination.

Did you know that the word *journal* originally was meant to describe a trip, a day-to-day record of travels, outward or inward?

It can be that for you. Enjoy the journey!

Cathy Johnson
artistsjournalworkshop.blogspot.com

Journal Page by Hannah Hinchman

5 mars 2010 Liten bakgata i ghettot i Rom.

6 mars 2010. Lunch ombord på planet Rom - Riga, med rött vin till.

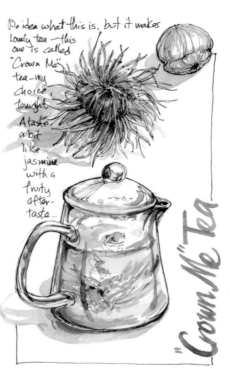

went to buy a teapot for a present and there was none... only this one... not sure...

Another K suggestion
CHILLI KISS
Luscious cinnamon tea and hot chilli in one great blend. A winter warmer with a spicy kick.

friday 08 january
my holiday is coming to an end soon... just one more weekend...

BASKET O' KITTEN - fries are extra!

No idea what this is, but it makes lovely tea — this one is called "Crown Me" tea — my choice tonight. A taste a bit like jasmine with a fruity after-taste...

"Crown Me" Tea

GETTING STARTED

Many journaling books start with a discussion of materials and supplies plus some warm-up exercises. Instead, we'll look at *why* you're holding this book in your hands. What's far more important than the materials you use is what you *do* with your journal—when and how you use it, what you put in it, what you want it to be.

What intrigues you about journal keeping? How did you get interested? How long have you wanted to do your own illustrated journal? Many people wait years to give themselves permission to jump in. So, why did you buy this book?

I'm guessing that the reason, in part, is because you hope for guidelines and inspiration so that you *will* keep a journal—or, if you've tried before and drifted off, so you'll keep at it once you start. I can promise both guidelines and inspiration from a variety of wonderful journal keepers.

That's really what this book is all about—discovering what you want and why you're here. I can't tell you—no one can. It's all up to you. But perhaps I, with the help of the wonderful contributors to this book, can assist you along the way.

Journal Artists
Top left: Nina Johansson
Top right: Liz Steel
Bottom: Cathy Johnson

EXPLORING WHAT YOU WANT

Ask yourself three questions. In fact, write the questions and your answers right in your journal or on a separate piece of paper that you can paste into your journal if you like. Answer the questions as well as you can—and know that your answers may change over time. That's fine. Journaling has a natural, organic evolution.

QUESTION ONE:
What do you want from your journal?

How you've imagined using a journal is important. You may not end up doing exactly what you imagined—or even wanting to do what you imagined—but unless you have a goal, a plan, *a vision*, you won't know where to start.

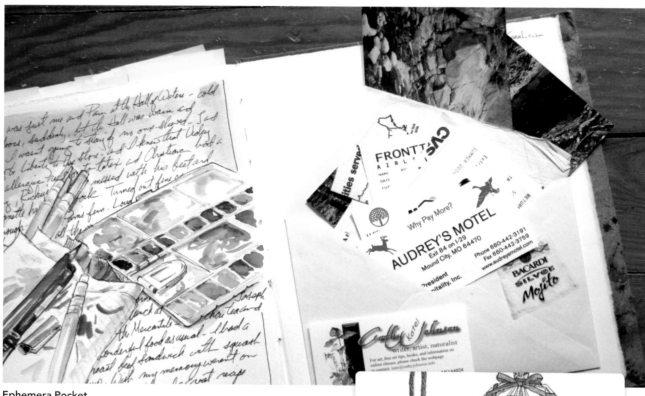

Ephemera Pocket
Glue an envelope on the back page of your journal for keeping your answers to the three questions in this section. It will be interesting later to see whether you've realized your goals or whether they've evolved into something new. (This envelope is handy for many different kinds of ephemera—business cards, photos, ticket stubs, boarding passes and other memorabilia that may end up pasted into your journal.)

I've received requests to illustrate children's books, and a nearby botanical expressed an interest in my teaching a workshop on keeping a nature sketchbook. It seems that doors are opening for me that I didn't plan on. I'm curious and excited to see where journaling takes me.

—Vicky Williamson

Celebrate Family Heritage
Vicky Williamson celebrates her husband's Swedish heritage with this page. Her varied journaling has led her in some interesting and unexpected directions.

QUESTION TWO:
What will go into your journal?

Will you focus on a theme or integrate anything and everything into its pages—sketches, plans, paintings, photos, memories? Do you want to include more art, more words, only one or the other, or a balance of both? Some artists like to keep travel journals or journals for family memories or a record of a special workshop. It's up to you.

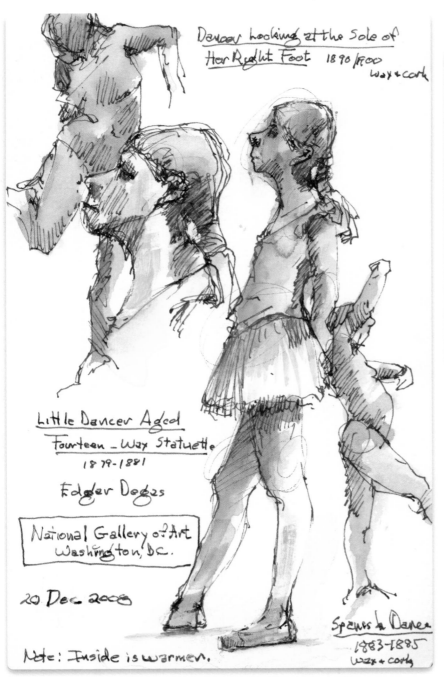

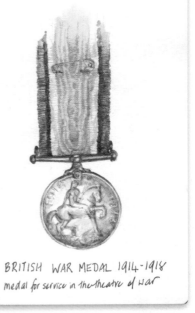

Family Memories
Alissa Duke has taken on the task of recording family memories in her journals. This is one of her great-grandfather's medals rendered in watercolor pencil, her favorite medium.

Watercolor pencils are excellent for sketching while traveling because I can take and use them anywhere. I can either use them as the main medium or just to add a wash to a pen drawing.

—Alissa Duke

Museum Study
Many artists record museum visits in their journals or use them for research. Here, Fred Crowley, a retired Marine colonel, studies the works of Edgar Degas in the National Portrait Gallery in Washington, D.C. Crowley used ink and luminous watercolor washes in a small, unobtrusive journal.

QUESTION THREE:
When or how do you see yourself journaling?

Do you expect to journal while sipping your morning coffee, on your lunch break, just before bed as you create a thumbnail overview of your day? Do you want to journal when something moves you? Do you see yourself journaling indoors or outside in a natural setting? While waiting? On a trip? All of the above? Do allow yourself the journaling time that you envision. It's important!

Set Your Goals

Think about these questions. Maybe you've always wanted to keep an illustrated journal to record your days or dreams or to learn from nature. And of course, do more than think about the questions: Write these plans and ideas down and set yourself a goal—or an array of them. Then set off in that direction.

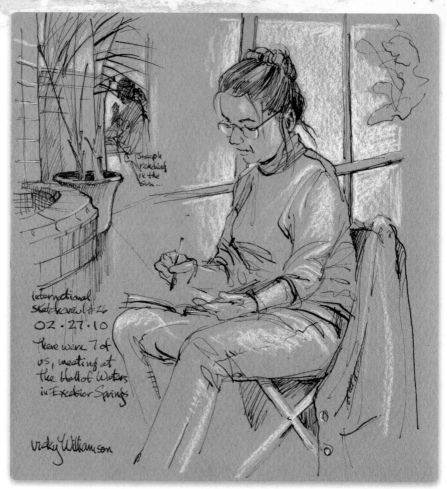

Journaling Inside
Vicky Williamson enjoys sketch crawls—group journaling sessions in an appointed place. She's comfortable working in her journal wherever she finds herself.

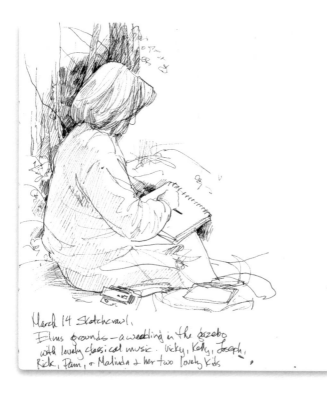

Journaling Outside
I find that working in a natural setting is always satisfying!

TIP KEEP IT UP

The way to get closer to your goal of improving your art is to keep making art. You'll see you're on the right path when you look through your journals.

TRY THIS
DRAW A JOURNAL MAP

Draw a journal "map" for yourself, right in your book. Some people do an actual imaginary road map; some make a topographical sketch or landscape; some draw a treasure island; some use a tree-of-life image; some even make an imaginary game board. Make your map as abstract or detailed as you want. Use whatever imagery works for you.

Your map can explore the journal experience itself (what you want your journal to become), point you toward what you expect to learn in your journaling, or perhaps simply plot your life—all of it or starting from where you are now—with intersections and signposts along the road. Put in the roadblocks or imagined obstacles as well.

Where do you want to go? Do you want to be a better piano player, a more relaxed person, a more disciplined one, a professional illustrator, a good teacher, a better parent or child, a designer? Do you hope to have more confidence in your art or to learn to really feel like an artist? It's your map—you figure it out! Think in visual images, use symbols, and have fun!

Journopoly Map
Your journal map doesn't have to be a map at all. Make an annotated list or chart or, like Jeanette Sclar, create a game board with your goals and imagined obstacles.

I'm quite sure my profession drives my art. Art is all about discovery and understanding for me, and it naturally follows that my architectural background, with its emphasis on presenting information graphically so that anyone can understand it, simply has to inform my art.

—Jeanette Sclar

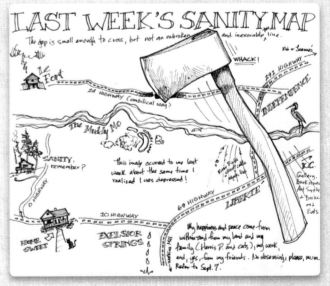

Sanity Map
You can do maps like this in your journal at any time to explore memories, an idea, a concept or even an emotion. This one really helped me let go of a stressful situation!

OVERCOMING FIRST-PAGE JITTERS

Some people find the first page in a new journal intimidating. They're overwhelmed with questions: how to start? what to put there? how to get past the curse of Dread White Paper? (It *is* just paper, you know—paper mills are making more as we speak.)

Don't be afraid of ruining that lovely book because, the truth is, you can't! It's *your* journal, and your time on this earth is far more important than a blank book. I've done all kinds of opening pages, but these days, usually I just jump in and start.

Somewhere on that first page I do put my name, address, e-mail and the words, "If found, please contact kate@cathyjohnson.info for a modest reward!" (Or I paste my business card inside with that same request.) I've always been able to retrace my steps and find my misplaced, wandering journal, but I know several friends who weren't so lucky. Happily, almost all got their journals back eventually because they put their names and contact information inside.

Add the date to the opening page of your journal because years later you'll kick yourself if you don't remember when you took that special trip, had surgery, stayed at that terrific bed and breakfast or met that new friend.

Comfortably Cluttered
Gay Kraeger puts all kinds of things on her opening page—art, calligraphy, return information, notes. Her approach is a great way to jump in! (She's on journal number fifty-six, after twelve-plus years of dedicated journal keeping.)

Clean and Simple
Fred Crowley's opening page is clean and direct—a title and a quote, giving a sense of what will happen inside. He often signs his work with a Chinese chop mark, and his work has an exotic feel to it.

Keeping an illustrated journal has been a life-changing experience for me. I see the same life-changing power of the journal with our students who journal regularly. I've found it doesn't matter how well you draw or paint. The power of the journal seems to be in just the doing of it.

—Gay Kraeger

TIP FIRST-PAGE IDEAS

- Skip the first page if you want! Once your journal is underway, let the first page tell you what to put there. Chances are you'll have developed a theme or direction by then.
- State your jounaling plans.

- Leave the page blank so you can create an index or table of contents later, once the journal is filled.
- Write a special quote or dedication.
- Paste in a sketch or inspiring photo or image.
- Design a montage.

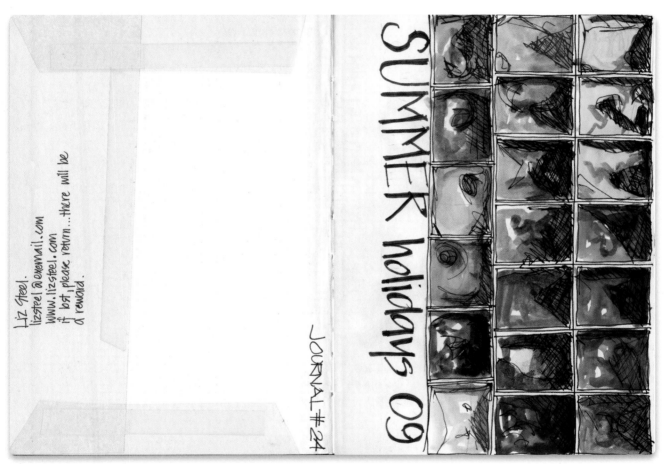

Palette Title Page
Do as our friend Liz Steel does, and create a new-journal tradition. On the first page of each new book, she likes to sketch her current traveling paint set. The effect is colorful and delightful, and she doesn't have any angst over what to put on that first page. Liz is an Australian architect who's been keeping a journal for only a few years.

A friend introduced me to watercolor pans in a field kit in December 2006. I instantly fell in love with them. Inspired by my friend's watercoloring and Danny Gregory's sketchbooks, I started my own watercolor journal in January 2007 with the intention of sketching regularly as "training" for a trip to Europe in September. Not only did I achieve that goal, but the almost-daily habit has become an end in itself

—Liz Steele

WHAT'S IN A NAME?

Does your journal need a name—perhaps to fit a theme or a mood or to help you focus? (Or, hey, just for fun!) Some of my journals have names; some don't. The name or title can help you remember what's in your journal, or it can personalize the journal for you. Make the title as descriptive or whimsical as you like. Use your own hand lettering, or use your computer to print the name and paste the printout onto the cover. You can print and paste whether your journal is commercially made or made by yourself.

If you like, you can create an index collage for the cover of your journal after you've finished it. Again, that works with either commercially made or handmade journals.

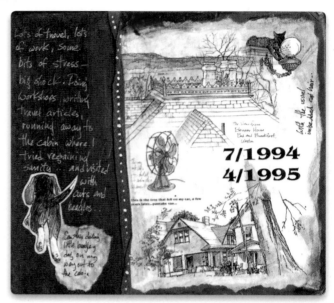

Dated Title

I've got a big stack of old square-format Pelikan books that I used for journals for years. To create a kind of index as well as to personalize this journal, I scanned favorite images from the finished book, did a montage and glued the result onto the cover. I added a bit of lettering and dates indicating the years that the journal covers, and the cover became infinitely more useful to me—as well as more fun to look at.

Whimsical Title

I glued a vintage playing card and a bit of textured red paper to the front of this blue journal. A little metallic paint and some rubber stamps gave me a silly, fun journal cover. I often use bits of polymer clay like faux sealing wax.

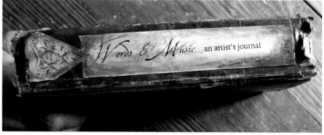

Personally Significant Title

The journal title *Words & Music ... an artist's journal* is a grateful nod to one of my first inspirations and mentors, Ann Zwinger. She always said that illustrated journals are like words and music. Of course, *music* is a metaphor for art.

I printed the title with a computer font called La Figura. Then I collaged it onto the spine and antiqued it in colors to harmonize with the old marbled paper of the book's cover.

TO SHARE OR NOT TO SHARE?

If your journal evolves into a more personal tool for growth—or venting—you may not wish to share all the details, even among fellow art journalists. Or you may. Such sharing can be helpful—kind of like a twelve-step program.

Try not to censor yourself. You need to feel free to put whatever you want into your journal; it's therapeutic. In order to do that, even the most extroverted may need to find ways to protect sensitive entries.

Sometimes friends, family or even interested strangers may ask to browse your artist's journal; they'd never ask that if it were your diary, but what we do as artists simply fascinates people. If there are things you'd rather a casual observer not see, you can paper clip pages together. Of course, you can also just say, "I'm sorry, this is my personal journal." Most people will understand. (I once forgot I'd done some life drawings of my husband in a journal and was a tad embarrassed when perfect strangers got to see more of him than I'd intended.)

One of my students vents in her pages and then writes over and over her venting in several directions. She gets the anger out of her system, but no one can read the words—a brilliant solution!

Author Hannah Hinchman suggests writing very, very small. Some great journal keepers of the past created their own personal code for keeping their words private. For example, Leonardo da Vinci used mirror-writing (my illegible handwriting is almost sufficient).

If you scan or photograph your images to share with friends, simply lay a piece of paper over any notes you prefer to keep private. Self-adhesive notes are great for this.

If you use photo-editing software, you can blur words. In Photoshop, create a rectangle with your selection tool directly over the words you want to hide, using a blur filter. Or select that rectangle and fill it in with color. You can write or sketch on the rectangle later.

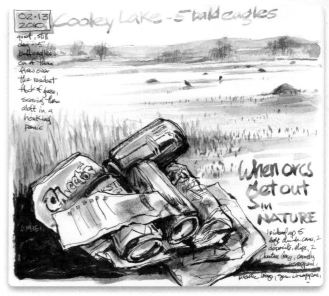

Venting
I sometimes use my journal pages to express my anger at vandalism or meanness or to deal with the anxieties life hands me. Pages like these provide an effective rmeans of expressing feelings and, if you choose to share those pages, you can raise awareness.

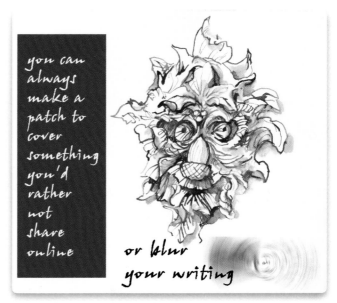

Private Matters
After scanning my journal page, I used a photo-editing tool to put a patch over the words I wanted to hide. Then I added other words on top of the patch.

TRY THIS
PRIVACY LIST

Come up with ideas of your own for protecting your privacy. Try one or two out in your journal and make a list of the others.

WHAT IF YOU MAKE A MISTAKE?

Define *mistake*. Often we put too much pressure on ourselves to be perfect. Ignore those mental tapes of remembered criticisms. The Inner Critic can take a walk!

Speed-sketching techniques can never be perfect. Neither can blind contour drawings you create without even looking at the page. *Who cares?* These images will act as triggers for your memory or will help you mark your progress toward being able to capture images in the way you want to. Don't tear them out or paint over them unless you *really* feel the need.

If you really, really hate an image, you can paint over all or part of it with gouache (opaque watercolor) or acrylic. Then either write on it or make a new image. (Be aware that acrylics can cause pages to stick together. Gouache doesn't.)

Sometimes, even a light haze of gouache can soften an image you don't care for. Simply paint a new image right on top of your "mistake" with a thicker, more opaque mixture.

You can redraw an image on a new piece of paper and glue it over the part you don't like, or you can glue the patch on first and then redraw.

Add interesting items like a business card, photo, ticket to a play, airline boarding pass or menu over bits you're not fond of. The pasted-on items may become an integral part of the page, telling their own part of the story. Collage over an entire offending page, if you must.

Write Right Over
It's hard to draw a moving cat! With a light application of blue gouache, I could cover the sketch that didn't work and write on top of it. Or I could have created a new sketch.

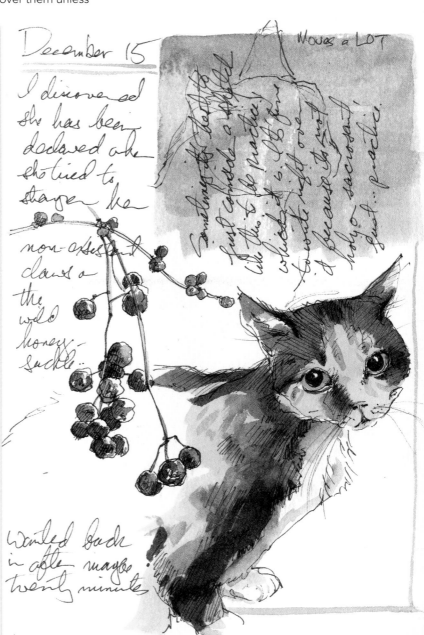

Edgy Cover-Up

Somehow this sketch of my sleeping husband just did not work. But I liked his ear. Now I kind of like the edgy energy of my ink scribbles over the offending areas.

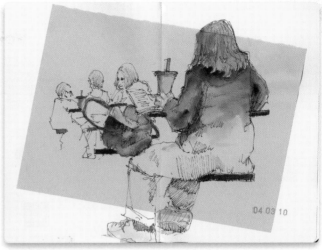

The Patch

Artist Fred Crowley uses Fabriano Ingres paper as a patch to cover drawings that "don't get off the ground or are clear mistakes." The patch adds a strong graphic effect, and placing it at an angle creates dramatic tension. Then he draws right over the patch for wonderful results.

TIP
EMBRACE MISTAKES

When you're tempted to tear out or cover a mistake, remember that one of the benefits of creating a journal is that your progress is right there to see, from your earlier journals to your later ones. Seeing how you've grown beyond past mistakes is very encouraging!

Collaged Card

I liked the top part of this page, done while I was rehabbing the kitchen, but the bottom sketch just didn't work. I didn't want to forget the wine tasting so, since the colors harmonized, I collaged the card onto the page.

JUMP RIGHT IN

Remember, it's your journal, and although you'll like some pages more than others, there really are no mistakes. Even a single, quickly drawn line can express a mood or capture a memory. So can a bold, angular scribble.

If you've ever started a journal and then faded, ask yourself why. Were your expectations too high? Did journaling take too much time? Did you get bored? Did you imagine your life wasn't interesting enough? Write down what you think was the problem, and then see whether you can find creative solutions.

Enlist the support of your family and friends. Make sure they know this is important to you and that you'll be a happier, better spouse, parent, child, sibling or friend if your time with your journal is respected. It's true! If creativity is thwarted, something within us withers. If you're traveling with others, you may need to do fast sketches and add notes or color later, but *do* it, in any case. (I've been at it so long, my husband worries if I *don't* journal.)

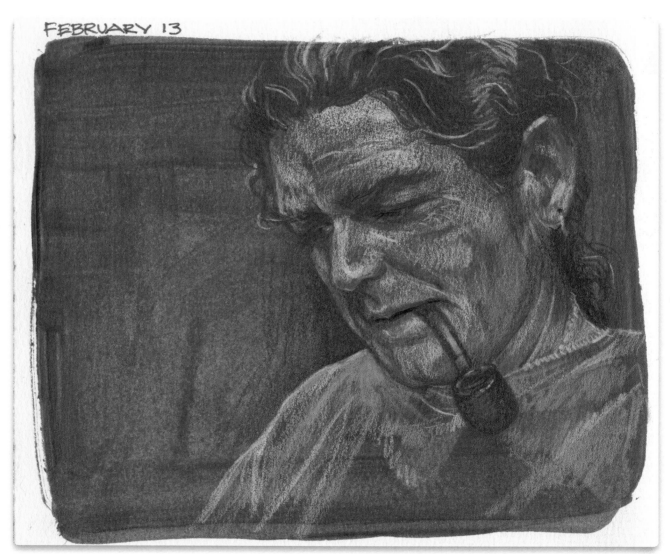

FEBRUARY 13

Feel the Heat
I pretinted a couple of pages in my journal with thin but bold layers of liquid acrylic and let them dry thoroughly. Then I let the color inspire me. My husband and I had been in the hot, hot desert, and the color seemed to suggest that intense heat. This sketch is colored pencil on that bold acrylic wash.

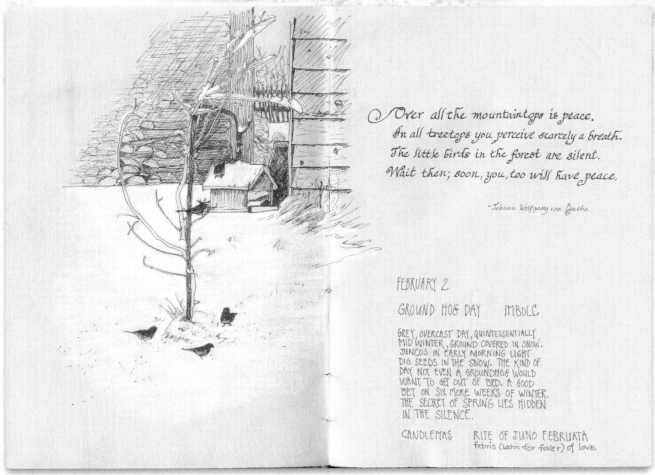

*Over all the mountaintops is peace.
In all treetops you perceive scarcely a breath.
The little birds in the forest are silent.
Wait then; soon, you, too will have peace.*

— Johann Wolfgang von Goethe

FEBRUARY 2

GROUND HOG DAY IMBOLC

GREY, OVERCAST DAY, QUINTESSENTIALLY
MID WINTER, GROUND COVERED IN SNOW.
JUNCOS IN EARLY MORNING LIGHT
DIG SEEDS IN THE SNOW. THE KIND OF
DAY NOT EVEN A GROUNDHOG WOULD
WANT TO GET OUT OF BED. A GOOD
BET ON SIX MORE WEEKS OF WINTER.
THE SECRET OF SPRING LIES HIDDEN
IN THE SILENCE.

CANDLEMAS RITE OF JUNO FEBRUATA
febris (latin for fever) of love

Feel the Peace
Maria Hodkins expresses a sense of peace with both her art and words.

January 16—1½" of
ice on level surfaces

Feel the Chill
Create a subdued, wintry mood with a different color—a thin wash of Payne's Gray really captured that chilly winter feeling. More Payne's Gray in darker values, a bit of opaque white, and touches of ink worked for this monochromatic journal page.

Don't you love it when the integration of all that we are can come together in one art form? When I discovered I could do it all in one journal, it integrated everything in my life. It's effortless now. And if too much time passes without journaling, I begin to feel like a piece is missing from my center. Keeping an artist's journal puts me at peace.

—Maria Hodkins

TRY THIS
GET YOUR FEET WET!

If you've never kept a journal before, now's the time to start. Doodle on a page, throw ink at it, finger paint if you like. Make interesting textures and let them suggest meanings to you. Try toning your paper with watercolor or acrylic and drawing or painting on that, so you're not staring at pristine white paper. The effect can be exciting and bold or moody and atmospheric. The color or texture may suggest where to go next, or you may just want to go wild.

PHYSICAL JOURNAL

Once you decide what you want out of your journaling and how to get there, then there are a few necessary matters of lesser importance to consider. One of these is what you will use as your actual physical journal.

Journal types and preferences are a very personal choice, and getting started is more important than finding the Perfect Journal. There's no magic trick to selecting a physical journal—actually *journaling* is what brings the greatest satisfaction. I've used everything from spiral-bound notebooks I picked up at the discount store to handmade books with the best watercolor paper. Although not all mediums will work as well on the notebooks, they're just fine for ink or pencil observations and note taking.

That said, I definitely do not suggest starting out with a commercial journal filled with cheap, slick, lightweight paper (unless you really like the feel of it). If you plan to work in a variety of mediums, you don't want to get frustrated before you begin!

Early Journals
I used school notebooks like these for years, before moving to something more sympathetic to an artist's needs. I have fifteen or twenty journals like this. Here, you can see notes from my college geology class many years ago.

Paper with a bit of texture is most versatile—just be sure to choose paper you like, that feels good to the touch and that doesn't have too much tooth or texture, so you can use a variety of mediums if you want to. A surface that's too rough can be frustrating. Some of the handmade papers, for instance, will catch your pencil or pen point and make lines that skip.

Stay away from a journal with paper that's overly absorbent. That's fine for Chinese brush painting, in which each stroke is supposed to show, but frustrating for just about anything else.

I personally avoid journals with very slick or lightweight paper, though many swear by the Moleskine type, especially for ink or pencil. (If you don't get the Moleskine specifically made for watercolor, you'll want to add a bit of soap or detergent to your paint water to make the paint adhere to the slick surface—or use watercolor pencils, crayons, colored pencils or something else to add color to your pages.)

If you plan to use watercolors, watercolor pencils, or even acrylics, you'll most likely want paper that's easy to write or draw on with pencil or pen, but that will take some wet media. (For obvious reasons oils don't work as well in a journal because your pages would need to dry for a long time before you could shut the book.)

Generally speaking, avoid those journals with lined pages, as well as those with inspirational sayings or art printed on the pages. This is *your* journal, and those lines or printed matter are far too limiting.

That said, I've seen some wonderful journals kept in old ledgers. *Muriel Foster's Fishing Diary* is one of my favorites. Begun in 1913, the diary covers thirty-five years of a Scottish woman's love affair with fishing. The French artist and illustrator known as Lapin also works on ledger paper to wonderful effect.

Many artists enjoy painting and sketching right on the pages of a printed book, but I find that limits me too much. There's no room for my own words, and I love the combination of my own text and art, which truly does give the feeling of an illustrated journal. I also need good paper to work on.

If journaling in a printed book inspires you, though, go for it. If working on old printed matter. bothers you, scan the pages, print them out and then work on them. Paste the scanned pages right into your journal. Alissa Duke recently

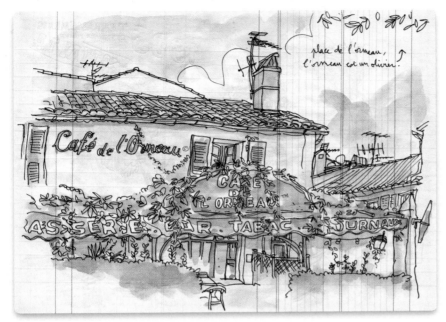

Café de l'Ormeau
Lapin lives and works in Barcelona, Spain, and does travel sketches—such as this one of a restaurant in Provence, France—that seem just right on lined ledger paper. He also works on graph paper, which gives an interesting gridded effect.

I go to the flea market a lot, and I started collecting old notebooks years ago. The quality of this old paper is amazing and, to my mind, the color of the paper, and all those lines add a lot to my sketches.

—Lapin

worked in ink and gouache on vintage sheet music for a wonderful effect.

Whatever you use, find a journal that will open fairly flat so that you can work in it easily. You may like a spiral-bound sketchbook or even a day planner. One traveling artist I know does lots of small sketches on these pre-formatted pages.

Some people feel that a spiral binding is too much in their way or that spiral-bound pages tear out too easily; others love them because they lie flat for working, photographing or scanning. Spiral-bound sketch pads are fairly inexpensive, so you can experiment.

Strathmore makes a spiral-bound watercolor pad (400 series) that I've used with pleasure. It alternates sheets of nice, hard-surfaced, cold-pressed (medium texture) watercolor paper with lightweight sheets of paper you can sketch, draw or write on easily. American Journey makes a similar spiral-bound notebook that a lot of people like.

A hardback journal is the choice of many journal keepers, myself included. Most open fully so you can work in them easily, and that hard binding can take a lot of wear—even abuse! I carry mine everywhere I go, so a sturdy binding is important to me. My journal often looks a bit dog-eared by the time I'm finished with it, but that's part of its charm.

Format and size are up to you. You may want to choose a journal that fits easily in a pocket, field bag or purse—or you may like working on a larger surface so your whole arm can move.

I've used just about every kind of journal available, and there are advantages and disadvantages to all of them. Mainly, I prefer those that easily open flat for journaling and scanning, that don't tend to snap shut as I work, and that are of a size that's comfortable for me. (My first handmade journal was an extreme landscape format, very wide but not very tall, and I quickly discovered how awkward it was to use.)

One way to get exactly what you want is to make your own journal out of the paper you really enjoy in the size and shape you like. I'm spoiled; I make my own journals now so I can have paper I love. That's usually a combination of hot press, cold press, and colored papers—even black. Sometimes I use 90-lb. (190gsm) paper but more often I use 140-lb. (300gsm) so it won't buckle when I use wet media.

OTHER MATERIALS AND SUPPLIES

First and foremost, just jump right in! Get started journaling, or if you're already doing it, keep it up. What you use isn't as important as actually journaling. A sketch pad and a pencil or pen are fine; that's what I used for years. And the nice thing about keeping a journal is that supplies can be simpler and more compact than those you'd use to outfit an entire studio.

But since most people like at least a bit of guidance, especially if they're just starting to journal, here are some of the basic materials.

No. 2 Pencil
A traditional no. 2 wood pencil from the grocery or discount store works just fine and is amazingly versatile. You can get a range of values and, depending on how you sharpen the pencil, a great variety of line widths.

No. 2 Wood Pencil or HB Mechanical Pencil
Eventually you'll want to explore the range of artist pencils, their hardness and softness determined by the ratio of graphite to clay baked into the lead, but for now, an ordinary no. 2 pencil is fine.

An HB mechanical pencil with a 0.5mm to 0.7mm lead is another good choice. It doesn't need a sharpener, which makes one less thing to carry!

Technical Pens
Try sizes .1mm, .3mm and .5mm.

Gel Pens
Gel pens are available everywhere these days, but the ink sometimes takes longer to dry than I like. A white gel pen

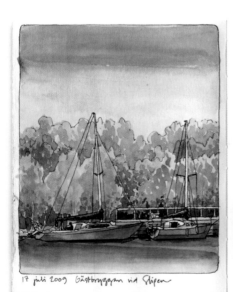

Ink pens, preferably fountain pens, and watercolors are my favorite mediums. I love trying out other techniques and materials, too, but I always return to ink and watercolors.

—Nina Johansson

Ink and Watercolor
Swedish artist and teacher Nina Johansson has kept journals for years in a variety of media. Here you see a composite spread that she designed using a waterproof technical pen with fresh, intense watercolor washes.

makes nice lines on a dark toned paper, though, adding a bit of sparkle to a mixed-media page.

Water-Soluble Pens

You can get some lovely grays by wetting water-soluble pen lines with water. The effect can be similar to painting. Leave the result as a line and halftone sketch or add washes of color.

Ballpoint Pens

Don't forget good old ballpoints! They're easily available virtually anywhere and often give lovely, subtle tones—almost like graphite, only permanent. You can get them in black, of course, but also brown, blue, red, lavender and green. Consider some of these offbeat colors for a beautiful color note. You can buy ballpoints with archival ink.

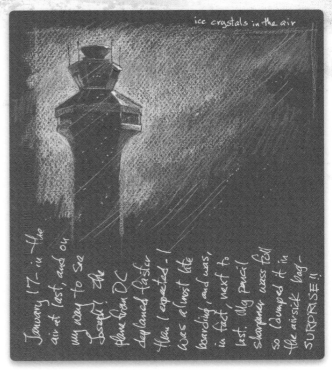

White Gel Pen Snow

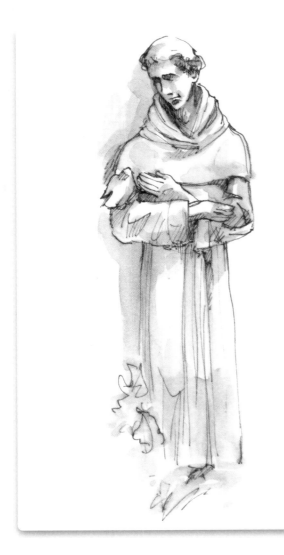

Ballpoint Pen
A single ballpoint pen is capable of a broad range of values. Use pens alone, add washes or colored pencil, or work on toned paper—they're very effective. It's the pressure on the pen point and the amount of hatching or crosshatching that gives you the value range.

St. Francis in Water-Soluble Pen
I used a water-soluble, fiber-tipped pen from the discount store for this sketch of my garden St. Francis,.I wet the lines to pull out soft halftone grays and then added light, subtle watercolor washes. It's a very handy journal technique, because you get lines and values with the same pen. If you want darker values, just add more lines and wet them.

Colored Pencils

Get a small set of colored pencils or choose open stock of only a few colors. I normally carry black, white, dark gray and a couple of the dark colors, like indigo and black cherry. These are lovely with watercolor washes over them. Some colored pencils are wax based; some are oil based. (I find oil-based colored pencils to be drier and scratchier, and they seem more likely to lift into my wash. Other people *love* them.)

Watercolor Pencils

Watercolor pencils are optional—some people love them for journal work; some don't. The brand is your choice. I use Faber-Castell Albrecht Dürer watercolor pencils when I want rich, saturated color that lifts easily with water, but I use Derwent when I want some of the line to show even after wetting it. You can buy only the primaries if you prefer—I like to mix my own colors right on the paper.

This medium works well on the slicker paper of a regular Moleskine. You can get some very nice effects with them, and they adhere well to the paper.

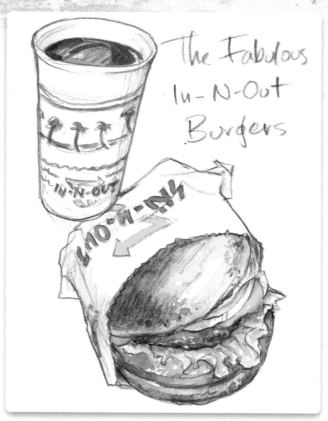

Colored Pencil Burger
I always carry a few dark colored pencils for quick sketches. The wax-based pencils won't smear as a soft graphite pencil will—nor will they lift if you do colorful washes over them, as I did here. My California-born husband had been telling me about these burgers for years, so when I finally got to have one, I had to sketch it. I could only put off eating for so long, though—I added color later!

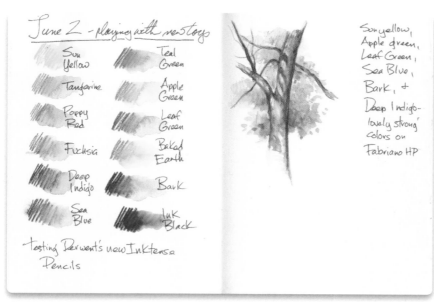

Watercolor Pencil Test
You can get very colorful effects with watercolor pencils, and they're wonderfully portable. Some colors change a lot when wet. You may want to have a test sheet nearby so you know what to expect. I often create a test sheet right in my journal, so it doesn't get away.

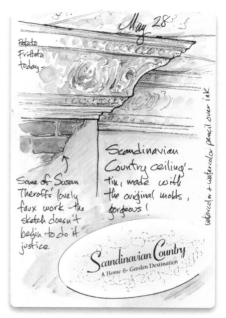

Watercolor Pencil Pigment Lines
Some watercolor pencils lift almost completely to blend when you wet them with clear water, and some will leave interesting lines of pigment like you see here. I like both effects.

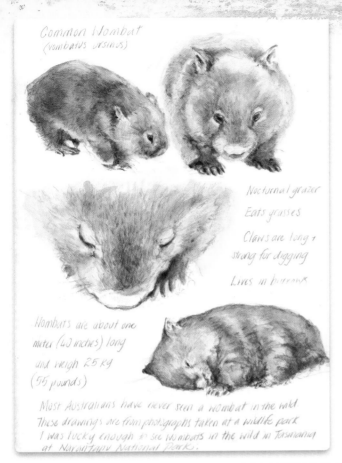

Common Wombat
(*Vombatus ursinus*)

Nocturnal grazer

Eats grasses

Claws are long + strong for digging

Lives in burrows

Wombats are about one meter (40 inches) long and weigh 25 kg (55 pounds)

Most Australians have never seen a wombat in the wild. These drawings are from photographs taken at a wildlife park. I was lucky enough to see wombats in the wild in Tasmania at Narawntapu National Park.

Watercolor Pencil Subtleties

Wombats are marsupials native to Australia, where Alissa Duke lives. She captured the effect of their soft fur with watercolor pencils, which can create very subtle effects—depending on the colors you choose, how you apply them and how you blend them. Alissa experimented with neutral colors and used a damp rather than wet brush to keep the effect soft.

I was experimenting as I went with this sketch. Over the course of a week or two, I went back and forth with watercolor pencil and water, adding a bit more detail.

—Alissa Duke

TIP
BLUE-GRAY WATERCOLOR PENCIL

Derwent Blue Gray watercolor pencil is wonderful to sketch with, and it provides a nice vibration when you put watercolor washes over it. It's moody and subtle, and it's definitely part of my everyday kit.

Like a water-soluble ink pen, this blue-gray watercolor pencil blends with a bit of water for subtle tones after you've done your basic drawing. It helps simplify your kit, too. All you really need is a watercolor pencil and a water brush for those times when you want to travel light. You may find the Derwent Graphitint Steel Blue looks and works almost the same—though the color is bit more saturated. I used both in the moody self-portrait to the right.

You can put a wash right over the watercolor pencil lines and lift as much or as little as you like. Many artists like to use watercolor pencils for preliminary guidelines because they can make the lines almost disappear. That can't be done with ink or graphite lines.

Be aware that even the same colored pencils from the same company may change formula after a while. That's why the blue grays in these two sketches are slightly different.

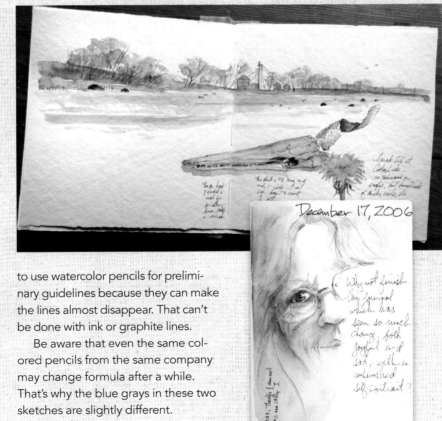

December 17, 2006

Inside the illustration: *This was across from the restaurant no end of little shops along the street.*

Small Set of Watercolors

I prefer artist-quality watercolors, but you can use student-grade if you like (some journal artists use good old water-colors made for kids). You can get pan colors, which are very portable or tube colors, which many artists prefer. Or fill your palette with tube colors of your choice and allow them to set for ease of transport. That's what I usually do.

Watercolor Crayons

Watercolor crayons or sticks are fun to work with, too. You can get a really bold effect sketching directly with them on your journal page and then moistening the sketch.

Pencil Sharpener

For graphite pencils, colored pencils, watercolor pencils and watercolor crayons, you'll need a pencil sharpener—a lightweight one that will take two sizes of pencils is great.

Watercolor Crayons
Here I used my watercolor crayons as big sticks of watercolor (which they are!), lifting color from the tips. I painted this near the ocean on Balboa Island, California.

TIP

PUNCH UP YOUR WATERCOLORS

Moisten dried tube or pan watercolors with a spritz of clear water a minute or two before painting. You'll be amazed at how much richer and more saturated the color is. I have a favorite little spritzer that goes everywhere with me. I got it in the travel section of my pharmacy.

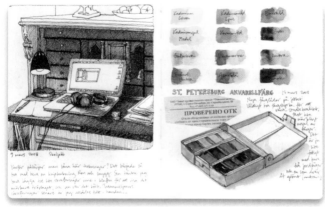

Small Plastic Watercolor Set
Nina Johansson gets a lot of travel miles out of this small plastic set. Note the color chart she made for herself.

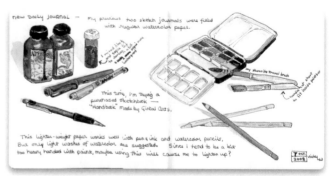

Watercolor Travel Set
Vicky Williamson enjoys trying out a variety of watercolor sets and tools. This is the Schmincke travel set, a sturdy metal box with plenty of mixing room for its size.

Palette Box

There are are dozens of small travel sets that are fine to start with—or use forever—but if you'd rather put together a custom set, you'll want a palette or watercolor box to put your paints into. My current favorite is an inexpensive folding plastic palette. You can find these at almost any store that sells art supplies. I have two—a small one and a larger one that fits in my backpack for serious plein air painting.

You can also choose a plastic or metal watercolor box. I have a repurposed Prang box from my school days in which I put my artist-quality paints, but there are a number of brand-new, empty, metal watercolor boxes out there that will take tiny half pans—about ½" × ⅝" (13mm × 16mm)—or full pans—⅝" × 1" (16mm x 25mm)—if you prefer.

I've even made a tiny travel set out of a candy tin (spray-painted white inside for a mixing area) and empty plastic pigment pans. Many journal keepers find that to be sufficient for their needs, since they don't plan on painting huge watercolor pictures.

Gouache Set

You may want to try a set of gouache (opaque watercolor) paints, either in tubes or pans. With gouache you can paint on toned paper—even black—with ease.

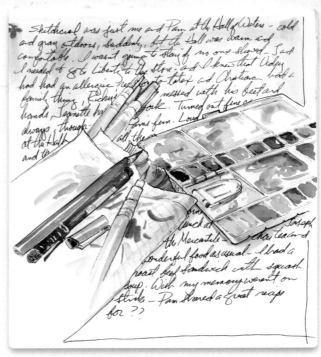

Folding Plastic Palette Box
My folding plastic palette fits right into my purse and goes everywhere with me. Here, you can see it with some of my waterbrushes and my ubiquitous paper towel or tissue.

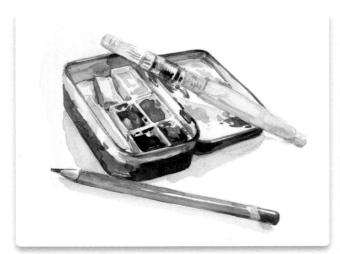

Tin Palette Box
Here's my little Altoids tin outfitted with the primaries and a couple of convenience colors, along with my favorite Derwent Blue Gray watercolor pencil and a waterbrush. This is a lightweight, inexpensive kit that's surprisingly versatile.

Gouache on Toned Paper
Fred Crowley often uses gouache on toned paper. This works beautifully when sketching animals, giving a dimensional look.

Small Water Container

Of course, if you're going to wet your paper or medium, you'll need a water container. I'm especially fond of small food-storage containers with watertight lids. They're great for sketching at home or on the road—but my water spritzer also does the job. A small, lightweight collapsible plastic water bucket works great in the field and resists tipping over. At home, a jam jar, drinking glass, margarine tub or an actual artist's water container works well. You may like to use two containers—or a divided container—so you always have clean water to mix with your paints.

Round Watercolor Brushes

Nos. 4 and 8 round brushes for watercolor are good standards; use larger sizes if you like. Investing in expensive sable brushes isn't necessary—there are quite a few serviceable man-made brushes out there by Golden, Daniel Smith, Loew-Cornell and others. My current favorites are Loew-Cornell Round Stain brushes and the 7020 Ultra Rounds from the same company. They hold a lot of water but still come to a wonderful point.

Sometimes when I'm working outdoors or traveling, I like to use a set of kids' watercolor brushes from the discount store. They're inexpensive and they pack well. None is very large, though, so you can only use them to work on fairly small sketches.

Flat Watercolor Brushes

You may want a ½-inch (13mm) and a ¾-inch (19mm) flat watercolor brush. Unless your journal is quite large, you won't need the bigger brushes.

Water Brushes

As the name implies, water brushes hold water right in their handles—but, of course, not very much. That can be a drawback, especially if you want to change colors quickly and need an unsullied wash, but water brushes are very handy for working on the spot where a whole watercolor setup might not be feasible. I've worked on planes, in cafés and in cars (not while driving!) with water brushes. I use Niji or Pentel (some other brands have leaked). I have all sizes of Niji water brushes, including the flats, because I enjoy the interesting marks these brushes can make.

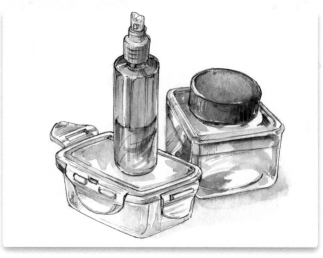

Water To Go
Water-tight food containers and spritzer bottles allow you to travel with a ready supply of water. A small collapsible container has to be filled with water when you're ready to use it, but it resists tipping.

TIPS

ABOUT BRUSHES

- You can sharpen the end of a round brush with a pencil sharpener to give you another handy tool. Dip the sharpened end into a rich pool of watercolor and draw with it like a pen.

- Brush sizes are relative. My no. 6 Round Stain is a bit larger than the no. 8 Ultra Round of the same brand. The same sizes of different brands will vary a lot.

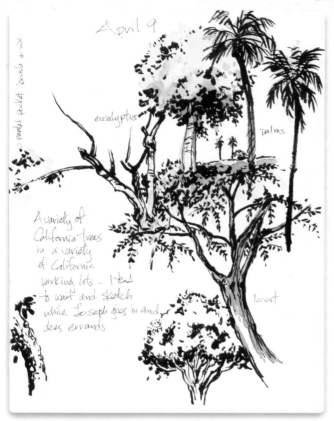

Brush Pen and Watercolor
The ink in a brush pen is usually waterproof, but you need to allow the ink to dry for a few minutes before adding color.

Brush Pen

You may also like a brush pen, such as a Pentel Pocketbrush, which dispenses rich, black India ink through a real brush end (unlike some of the stiffer "brush" markers). On most papers, the ink dries enough within a few minutes to allow you to paint over it.

Neutral pH Glue

You need a good glue for when you want to add a touch of collage. Elmer's, PVA glue and YES! Paste all work fine, but YES! is water-soluble. Sometimes that's what you want; sometimes it's not. Glue stick adhesives may let go over time, so I don't recommend them.

Put It All Together
Liz Steel sketched her whole kit. This is what she takes when she travels—a couple of metal watercolor boxes (one is tiny!); a selection of colored pencils, pens and brushes; liquid mask; and whatever other essentials are called for, depending on where she's going. Many of Liz's pages are a joyful exploration of the everyday.

My sketchbook journal is the celebration of the little things in life—the everyday becomes special and worthy to record, and journaling is a great way to realize how much we have to be thankful for—even in hard times.

—Liz Steel

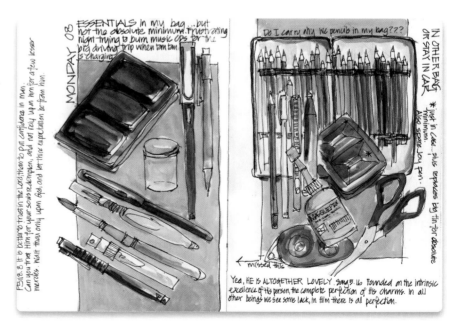

BRANCH OUT!

As I said, a journal and a pen or pencil are really your only necessities, and that's all I used for more years than I care to count. But trying other materials and media is part of the fun.

Try Color!

Color is not only fun, it also adds a lot to your page. Think of what various colors convey: Red is exciting and hot; blue can be soothing and elegant; green makes us think of summer. Use color to enhance your subject or express how you feel.

If watercolor is daunting, try a bit of colored pencil—or even kids' crayons or markers—on your pencil or ink sketch. These media are fun. Some professional artists use them, too.

Try Ink!

If ink is daunting, draw first in pencil and erase what you want after adding the more permanent ink lines. The Journal Police aren't going to arrest you if you prefer laying in some guidelines. It's whatever makes *you* comfortable that's most important. And truth to tell, professional illustrators often draw in pencil first, then add ink, then color. There is no right or wrong here.

That said, when you restate or redraw a line where you actually want it, it's often pleasing to see the slight vibration of the old line near the new. Remember, there are no mistakes. It's your journal—you can show it or not show it, but you'll always learn from it.

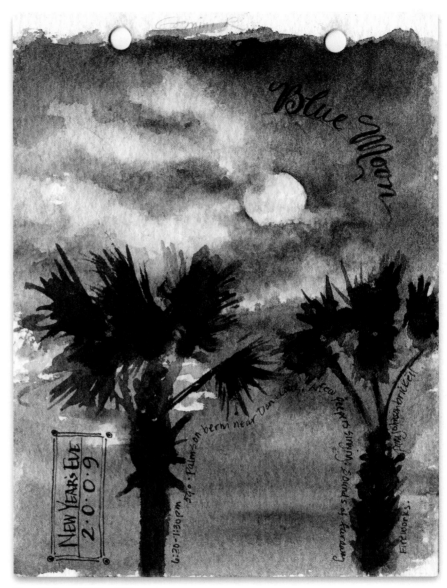

Blue (Pink and Yellow) Moon
Pam Johnson Brickell used deep, intense blue most effectively to capture that beautiful South Carolina full moon. Notice how touches of prismatic pinks and yellows enhance the sense of bright moonlight.

Try Collage!

Sometimes you want to add a bit of collage, or just adhere something to your journal page. It's fun to add a ticket stub, a small photo, a label or other similar item. Leave a space if you think you might want to include something like this. You can also use a collaged element to cover an area that you don't like.

Of course, you may want to go all out and create a serious, many-layered collage on your journal pages. Collage can lend a rich, interesting effect.

Enjoy all the tools at your disposal. Anything goes!

Simple Collage

Each of Ellen Burkett's strongly graphic journal pages tells a story we want to hear. Here she used a bold but simple bit of collage to cover something that she preferred to keep hidden. Combined with this powerful image, the collaged covering adds an even stronger sense of mystery.

The thing that inspires me to journal is the desire to make

some sort of impact or statement—to make a point.

—Ellen Burkett

All-Out Collage

This is an art journal-type collage, assembled in many layers, with rubber stamping, calligraphy and other effects. It was a lot of fun to do, but it's too time-consuming for me to attempt every day.

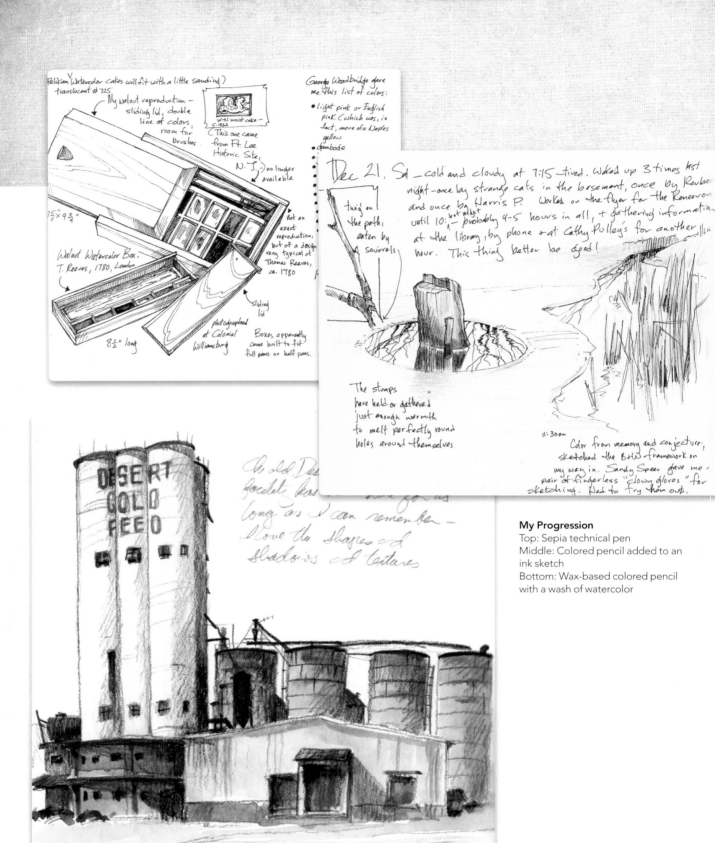

The old Desert Gold
Feed[s] has been there as
long as I can remember —
I love the shapes and
shadows and textures

Pelikan (Watercolor cakes will fit with a little sanding) translucent #725

My walnut reproduction — sliding lid, double line of colors, room for brushes

7⅝" × 4¾"

Walnut Watercolor Box: T. Reeves, 1780, London

8¼" long

sliding lid

Not an exact reproduction, but of a design very typical of Thomas Reeves, ca. 1780

photographed at Colonial Williamsburg

Boxes apparently came built to fit full pans or half pans.

W-N moist cake — c. 1822

This one came from Ft. Lee Historic Site, N. J. — no longer available

George Woodbridge gave me this list of colors:

- Light pink or English pink (which was, in fact, more of a Naples yellow
- gamboge

Dec 21. Sat — cold and cloudy at 7:15 — tired. Waked up 3 times last night — once by strange cats in the basement, once by Reuben and once by Harris P. Worked on the flyer for the Rendezvous until 10:— last night — probably 4-5 hours in all, + gathering information at the library, by phone + at Cathy Pulley's for another hour. This thing better be good!

twig on the path, eaten by squirrels

The stumps have held or gathered just enough warmth to melt perfectly round holes around themselves

11:30 am

Color from memory and conjecture; sketched the Botel framework on my way in. Sandy Speer gave me a pair of fingerless "clown gloves" for sketching. Had to try them out.

My Progression
Top: Sepia technical pen
Middle: Colored pencil added to an ink sketch
Bottom: Wax-based colored pencil with a wash of watercolor

TEST DRIVE

If you're an old hand at creating art, you already know what mediums you like best—what feels the most comfortable or allows you to express yourself quickly and with authority. Because your journal is a very personal place to express yourself, explore your life and record your impressions, you may want to journal with those old favorites, at least at the beginning. For the first ten years or so that I kept an artist's journal, I worked almost exclusively in black or brown with a pencil or technical pen. For nature observations, studies and research, the pens worked beautifully—nice crisp details! And of course, sketches of my cats or my husband and quick impressions of the people in meetings worked well in these mediums. Both are highly portable and relatively unobtrusive—which is good when you want to sketch without disturbing the people around you.

Later, I added colored pencils to my tool kit, since they usually don't smear and are wonderfully portable. Usually, to keep my supplies simple and portable, I chose black or a single dark color as a sketching tool, but I found I liked a bit of color added, too.

Finally, since I'm primarily a watercolorist, I let my two passions—journaling and painting—begin a tentative conversation in the pages of my sketch journals, and I was in love!

Now I enjoy using my journal as a place to explore my life and travels as well as new mediums and materials. I test my paints or pencils on these pages and often write notes as to what's what. I try out new brushes, colors, pens—and learn as I go. Sometimes I still use only a pencil or technical pen. I let my available time and materials, the subject and my mood dictate.

Your personal journal is a wonderful place for this kind of exploration.

WHAT CAN YOU TEST?

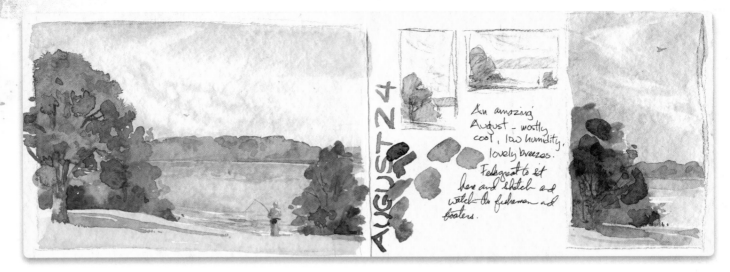

Your personal journal is the perfect place for testing the artistic waters. You can play with a new medium or technique, try out different colors and their effects, or consider a variety of formats—and feel completely free. Write poetry, if you want. Explore in words as well as pictures.

Sometimes you may want to share something that didn't work the way you thought it should—an ink advertised as waterproof that lifted when you painted over it, a watercolor pencil that fades over time, even in a closed book (I ended up with a pink cat once!)—and ask for suggestions from other artists. Many of us now belong to online art groups and photo-sharing sites like Flickr and Picasa. We invite others to take a look at our work and offer feedback.

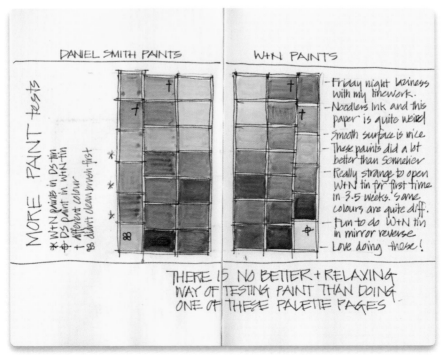

Paint Test
Liz Steel finds that her journals the perfect place to test paints.

Ink Test
Oops! This ink was supposed to be waterproof. Hmm, maybe not.

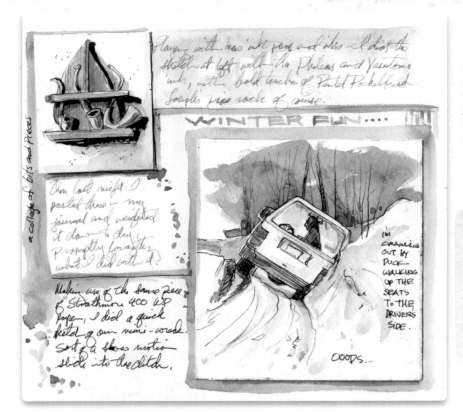

Design Test
The two images on this page were done at different times on small scraps of paper that were handy. I pasted them into my journal and tied them together on the page with text and color. Plain old school glue did the job.

TIP

AVOID STICKY PAGES

Some artists choose to work on only one page of a spread and leave the opposite one blank, so smearing or sticking isn't such an issue.

There are times when I find myself with a burning need to sketch but have no art materials at hand (this used to happen more often, before I made tiny journal kits for each car and my purse). Don't let the moment pass you by. Grab *any* kind of paper—a deposit slip, a used envelope, a paper napkin—and whatever medium is at hand. Your ballpoint pen (or one you borrow) will work great. Just get the image down! You can paste it into your journal later.

Some mediums work well in journals and some less so. Oils generally take too long to dry to be practical for a journal, although some of the fast-drying ones might work if you don't mind leaving your journal open until the page dries. Acrylics can work, but be aware that a thicker application of paint may make your pages stick together. You can lay waxed paper over the acrylic images or spray the pages with a fixative or sealant to alleviate that tendency, but I just apply acrylics in thin layers instead. Pastels are expressive tools, but you'll probably want to either use pan pastels, which make less dust, or add a fixative to set the image.

Jump right into testing your supplies! If you're new to the game, this play will give you confidence and show you what your materials can do. If you're an old hand, think of these exercises as warm-ups.

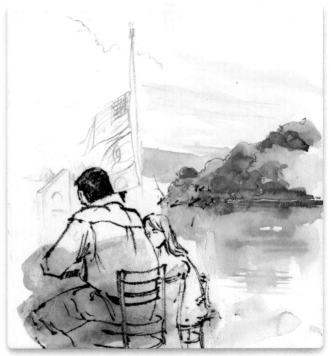

Unusual Material Test
I didn't have my journal when I decided to combine lunch with shopping, but I captured the people at the next table on my paper napkin, which I later collaged onto a page that already had a variety of casual beginnings. I liked that the napkin became semitransparent and showed the color below!

GRAPHITE PENCIL TESTS

Graphite pencils are the most basic tools of all and often the most easily found. Use them for quick sketches, halftone studies and complete drawings—or just do some light pencil guidelines that you can go over in ink or paint later.

See what your pencils can do. Make all the shades and marks that you can think of. The next time you journal, you may decide to pick up one of these simple tools first.

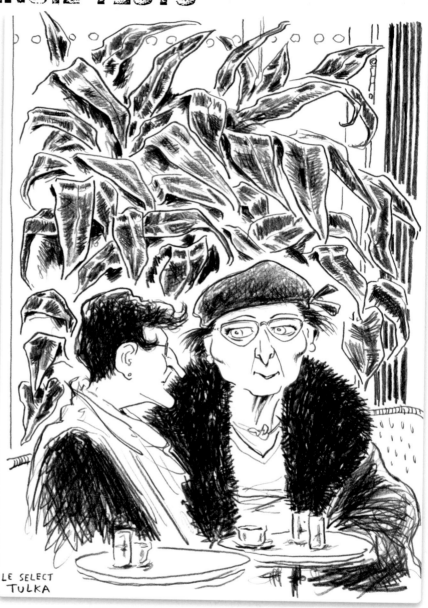

What Graphite Can Do!
If you ever thought that pencils were boring or not versatile enough, Rick Tulka's images will set you straight in a hurry. It's all in what you do with your tools.

TRY THIS
EXPLORE THE VALUE RANGE OF ONE PENCIL

One Pencil Plus Pressure
Make a range of values with a single no. 2 or HB pencil by applying more and more pressure with each swatch. Just scribble. You'll be surprised how adaptable one pencil can be.

One Pencil Plus Crosshatching
With one pencil and repeated hatching or crosshatching, create a value range from the lightest lights to the darkest darks. Notice how quickly dark areas build up.

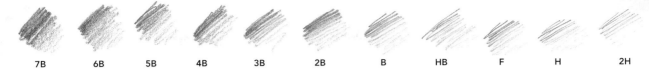

| 7B | 6B | 5B | 4B | 3B | 2B | B | HB | F | H | 2H |

Value Range of a Pencil Set

Pencils range from 9H (a very hard lead that makes a pale, precise line) to 9B (a very soft lead capable of making the blackest blacks). Soft leads tend to smear more than hard leads, so I mostly use leads in a medium range, HB to 2B. Spraying fixative on a completed sketch can also help prevent smears. You can buy sets of artist pencils, some with a more complete range of values than others.

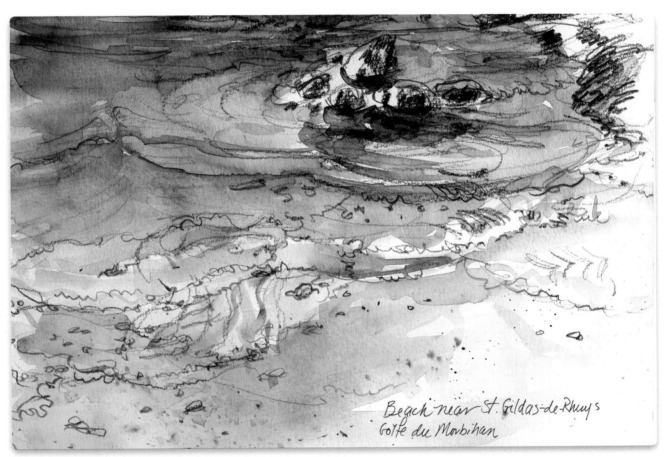

Beach near St. Gildas-de-Rhuys
Golfe du Morbihan

Soft Pencil Plus Watercolor

Laura Frankstone makes energetic, expressive lines with soft, oil-based pencils and often adds juicy watercolor washes.

I love the sensuous texture of the lines and the smoky darks I get with an 8B pencil. With graphite that soft, you can skate along the surface of the paper, swooping and curling as your fancy takes you.

An 8B graphite pencil does smudge a lot—that's the downside. Oil pencils are a great additon to my sketching kit. The extra soft ones are the equivalent of an 8B graphite pencil—without all the mess.

—Laura Frankstone

ONLINE EXTRA

For a free downloadable PDF of an interview with Laura Frankstone, go to: http://ArtistsJournalWorkshop .ArtistsNetwork.com.

TRY THIS

EXPLORE THE VALUE RANGE OF ONE PENCIL

Chose a subject that's fun to draw, and explore the value range of a pencil. I drew a favorite old pottery pendant, paying attention to shapes, planes and values. Do the same, testing the variety of marks you can make with your pencil.

1 Start with a simple line drawing of your subject.

2 Then build up light tones to begin giving it some mass and volume.

3 Add darker values by pressing harder on your pencil.

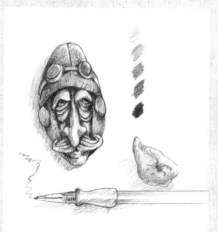

4 Here you can see the finished drawing with a value scale and my tools.

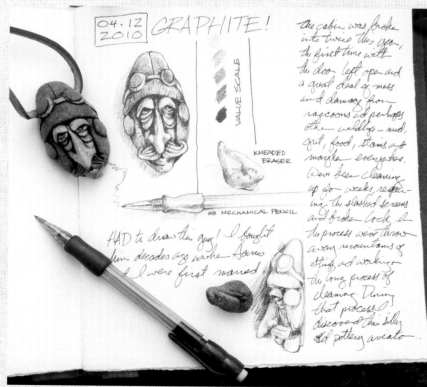

5 Since it is my journal, I wrote a bit about where the face comes from and why I sketched it, making this journal entry very personal. Here you see the page photographed with the actual objects and tools—a mechanical pencil, a kneaded eraser and that funny, old pottery pendant.

PEN TESTS

A lot of artists like to jump right into a journal page with ink—no preliminary pencil guidelines—going "lead free." It's like downhill skiing—you're in control, but not entirely. It's also liberating. If you make a line where you don't want it, there's no erasing. Just make another line where you prefer it and let the re-statement provide energy.

You have a lot of choices! Technical or artists' pens often have waterproof ink, so you can put watercolor washes right over them. (In cooler or humid weather, you may have to let them dry longer to avoid having the lines lift or smear.) These pens used to be available only in black, brown and red. Now you can find a wide range of colors.

Gel and ballpoint pens are almost universally available. They also come in an array of colors. Be aware that they can take longer to dry than some other pens. I only use them occasionally in my journal because their ink might smear when I close the book.

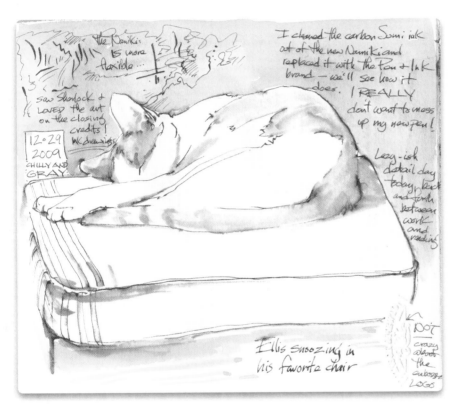

Fountain Pen and Watercolor
You can do ink tests with a subject and see how they work with overwashes of watercolor. Here I was test-driving a new fountain pen and several kinds of ink to see what would work best with watercolor.

PRAISE FOR RESTATED LINES

I like to watch and memorize, then draw, restating the lines if the first ones aren't correct. I remember in some figure drawing classes how people would erase an incorrect line They'd then draw the same line instead of drawing in the new line before erasing.

It is fun to watch the movement as I capture the image, and I also like leaving the lines in. That's why I like my fountain pens and technical pens; I have to live with what I put down. If I use pencil, I'm more judicious in my mark making. It really slows me down. I try not to erase.

—Fred Crowley

TRY THIS

TECHNICAL PEN TEST

Start with what's most easily accessible—in this case a technical pen, popular with scrapbookers, quilters, illustrators and fine artists—and do some tests as you did with pencil, varying pressure or suggesting values with hatching or crosshatching.

I did this test on the back page of my journal so that I'd have it handy. In the second row I explored the variety of sizes in my set of pens.

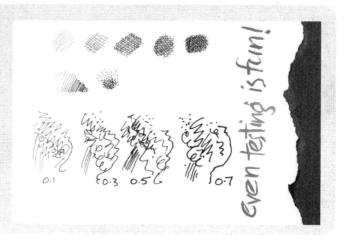

Touches of White Gel
Here I made a bright blue outline and added details and sparkle with a white gel pen after I'd laid in the watercolor washes.

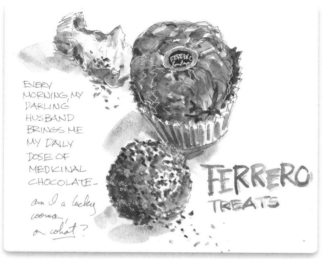

Ballpoint Grays
I got a nice set of grays with a black ballpoint pen here. Notice my value chart at the bottom, done with varying pressures on the pen.

Vibrant Color
Nina Johansson went wild with color, testing her set of pens in unexpected ways. Notice her varied lines as well as the way she uses hatching and crosshatching to build up a wide value range.

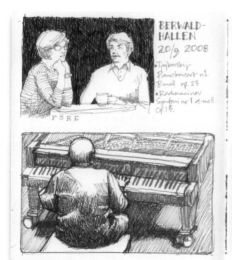

Fountain pens are portable and fun, especially if you find one with a flexible nib. Dip pens can be flexible, rigid, angled, pointed or rounded—lots of different nibs are available to give you the effect you want. You can use them with India ink, inks with shellac in them, sepia inks and even acrylic inks, none of which you'd want to use in your fountain pen because they tend to clog the works.

Don't have a selection of nibs? Try a sharpened dowel, a brush end you've brought to a point with a pencil sharpener, a bamboo skewer or a twig you've picked up from the ground. Be inventive! You can get some wonderful effects at virtually no expense.

Bamboo pens are another option. They're inexpensive and fun, and they come in several sizes, but for journal work, the smaller bamboo pens may be best.

Do take good test notes! You'll be surprised how quickly you forget what kind or size of pen you were using. You might even want to write down the brand name and model of the pen, because some work like a dream, some create ink blobs and some have a scratchy feel against the surface.

Bamboo Pen Sketch
Bamboo pens aren't flexible like some metal-nib pens or quill pens, but you can get some lovely effects. Touch the paper first where you want the line to be boldest. For a linear watercolor effect, make a pool of wash and dip the nib into it—then apply the watercolor like ink. You can even apply liquid mask with these tools.

TRY THIS

DIP PEN TEST

Try out a dip pen or two or as many as you can find. If you're like me, you're liable to have everything from crow quills to lettering nibs on hand. You can get some wonderfully variable lines if you use a flexible nib, depending on the pressure you put on it. You can even get some variation in line width or density as the ink runs off the nib, as I've done with several nibs in the ink test here. (Again, just be sure your lines are dry before closing the book, or you'll make a linear Rorschach test.)

COLORED PENCIL TEST

Colored pencils are terrific sketching tools—they're lightweight, colorful, portable and mess free. No problem going through airport security, either! You can get by with one or two, or you can buy a whole set.

My personal favorite journal effects involve a quick sketch in dark colored pencil, such as black, burnt umber, black grape or indigo, then watercolor washes laid in either on the spot or later. You can see examples of that approach throughout this book. The lines provide a framework and allow me to dash in color.

Of course, colored pencils can be more than sketching tools. They can giave you amazing bold or subtle effects.

Colored Pencil Plus Wash
I did a quick colored pencil sketch of geese at a nearby lake in one of my little folding journals. Then I added the color wash while sitting at one of the picnic tables. Wax-based colored pencils won't lift or smear when you wash over them.

TRY THIS
COLORED PENCIL SKETCH

Pick your favorite colors or the ones that fit the season or subject and fill a white journal page with a quick sketch or a more involved study. Try using a single color and emphasize the value range. Or try using just a few colors, such as the primaries, and experiment with layering to achieve more subtle colors.

Now, try the same exercise on colored or toned paper. Which paper captures the effect you want? If your journal doesn't have colored paper, work on a separate paper and paste the result into your journal.

Traditional Colored Pencil
The traditional colored pencil approach is to use a variety of colors, which works nicely on toned paper. (You can add these papers if you make your own journals—or pick up a journal made with tan recycled paper.)

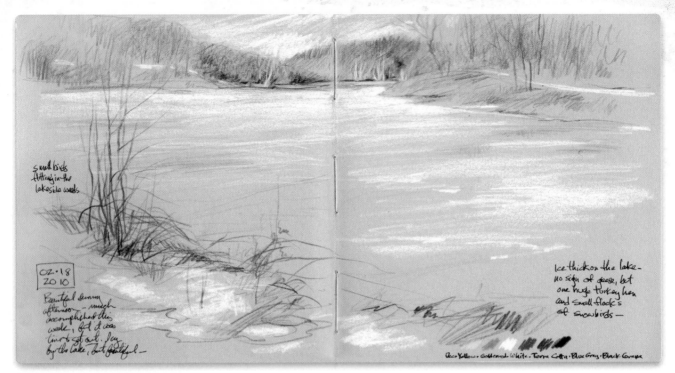

Limited Color on Toned Paper
Sitting by the lake made me cold, so I did this two-page spread quickly with a minimum of wintry colors. The toned paper gave this sketch unity. Make color samples right in your journal, as I did, to remind you what colors you used.

Bold Colored Pencil Plus Ink
Your composition can be as complex and graphic as you like. Ellen Burkett designed this beautiful page with a strong visual impact to tell a story. She used fine black ink lines with colored pencil to explore colors, patterns and textures. The broken border invites us into the picture.

WATERCOLOR TESTS

You can find a lot of terrific books on watercolor techniques that cover virtually everything: types of washes, pigments, watercolor paper, as well as techniques both basic and advanced. My own *Watercolor Tricks & Techniques* covers all those topics. For larger works and serious paintings, I recommend getting a book of that sort or perhaps taking a workshop or a class or two.

For your personal journal I recommend a different approach. No need to worry much about managing a large flat brush or a smoothly graded wash. Dashing in a bit of color can bring the simplest image to life. Many journal keepers use paints meant for kids or students, and if that works for you, go for it! Artist-grade paints are generally more saturated and, if you choose well, they're more permanent (you can usually find a paint's lightfastness rating right on the tube).

Professional-grade watercolors do cost more, but they keep their quality longer, lift more easily, and go a long, long way. If price is a consideration, stick with the primary colors (red, yellow and blue), maybe a warm and cool of each, and perhaps a couple of convenience colors. My little homemade travel box contains Transparent Yellow, Quinacridone Red, and Phthalo Blue, plus Burnt Sienna and Payne's Gray. Some people also include a green.

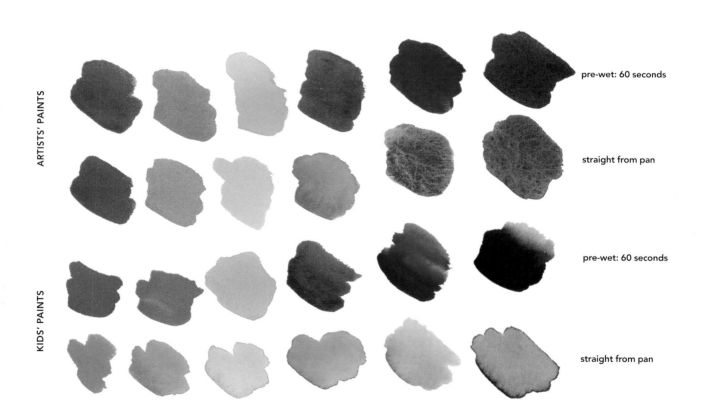

ARTISTS' PAINTS

pre-wet: 60 seconds

straight from pan

KIDS' PAINTS

pre-wet: 60 seconds

straight from pan

Kids' Watercolor vs. Artists' Watercolor
How you use your paints matters more than what brands or types you choose, especially if you're just getting started—and even more so if you're using pan colors rather than tubes. Pre-wetting the cakes of color with clear water brings them to life and makes them much easier to lift and mix, whether you choose paints meant for kids or the Good Stuff.

Well-Placed Color

Fred Crowley used just a bit of strong, saturated color to bring his ink sketch to life. There's no need to paint the whole page; sometimes you make the most impact with a few well-chosen strokes.

Six Watercolor Techniques

These quick approaches seem made for journal work. No. 1 shows an ink sketch with washes laid in fairly carefully, following the lines. No. 2 is looser—good for when you're in a hurry! In no. 3, the lines still provide a framework, but the page is moistened with clear water and the wet-into-wet color is laid in as the water loses its shine. For no. 4, I just captured a suggestion of the colors I saw with no attempt to follow my sketch. No. 5 gives the greatest control with straight water-color washes over a pencil drawing. Each color dries before another is added. No. 6 merely shows an indication of where the colors appeared on the faucet handle.

TRY THIS

SEE WHAT YOUR BRUSHES CAN DO

Put your brushes through their paces. If you're new to watercolor, you'll learn how to apply color and make it go where you want. If you've bought a new brush, you'll see what it can do.

Many journal artists use water brushes. They can achieve what they need with a small set of paints and a few of these handy tools that carry the water supply right in their handles. There are several brands and a number of sizes to choose from. Whatever brushes you end up with, test them to see how you can expect them to perform.

You can also get paint brush pens—brushes prefilled with color. Some are artist grade and some are made for kids. Either type is fine for journaling. For more versatility, you can mix the colors or dilute them. Some artists pour out the prefilled color, rinse the reservoir well and then fill it with clean water for an inexpensive set of water brushes they can use with their preferred paints.

Paint Brush Pen Play
I enjoyed playing with this kids' set of prefilled paint brush pens, just checking out what they do.

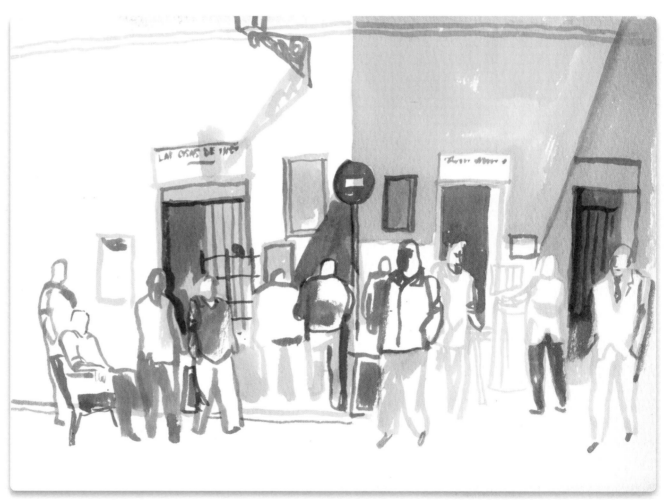

Color Economy With Water Brush
Spanish artist Enrique Flores fills a handful of water brushes with his own watercolor for travel sketching. The necessarily limited color choices make for a strong, graphic image. He achieves deeper values by applying new layers of paint once the first washes are dry.

I've been using water brushes loaded with watercolors for the last six years or so, and I find they're quite convenient for quick sketches on the go—especially on cold days.

—Enrique Flores

Another brush-drawing option is a brush pen filled with India ink. Brush pens were originally used for traditional Chinese brush paintings, calligraphy and manga work, but many journal keepers have found them to be lively sketching tools, capable of variable lines from delicate to bold. This is especially true of brush pens with real brushes rather than brushlike fiber tips. (But even the fiber-tipped variety has its appeal.)

Whatever brushes you end up with, whether traditional, water brushes, paint brush pens or brush pens, test how they perform.

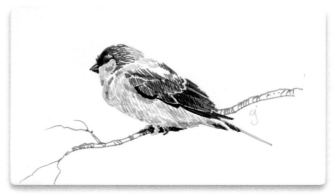

Kids' Aisle Tools
This little bird was done with a set of inexpensive markers from the kids' aisle. You can see there's not as much variation in the line weight with these less-flexible tools. Fun though!

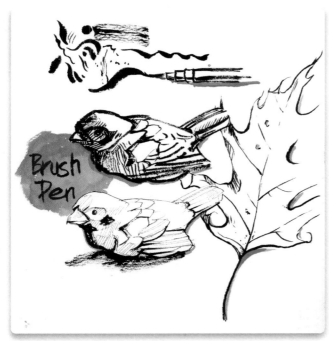

Line Work Plus Color
You can use a brush pen filled with India ink for line work and then add a bit of color, as I did on this carved wooden bird.

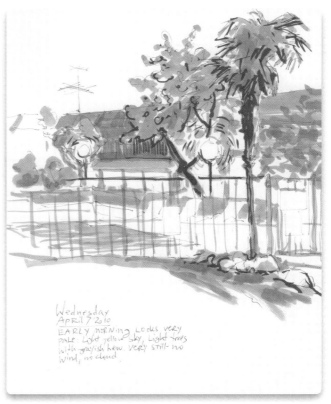

Fiber-Tipped Marker
Don't discount fiber-tipped markers! Nina Khashchina finds that a set of grayscale markers is convenient for making value sketches in her daily journal. Here she's captured the feeling of early morning.

GOUACHE TESTS

All the term *gouache* really means is opaque watercolor. I enjoy the freedom this medium offers—no need to protect or paint around lights, and I can fix a mistake easily. It's just a fun medium! Gouache has been much more popular in Europe than in America. It's gaining ground, though, and it works beautifully in journals. Gouche dries quickly, won't make pages stick together, allows you to paint over and correct areas you may not like, and looks great on toned paper.

Try it out! Buy an inexpensive set, fill a small palette or add a bit of opaque white to all your watercolors. (Have a palette reserved just for this, though, to keep the opaque color out of your transparent watercolors.)

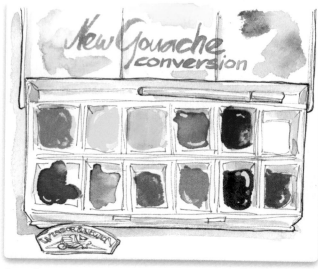

Gouache Replacement
I replaced the regular watercolors in this small plastic palette with gouache, which works beautifully for on-the-spot sketches.

Rounded Shapes and Hazy Effects
Ellen Burkett used a bit of opaque color and subdued tones to describe the rounded shape of the little Buddha and give a mysterious, hazy effect to the text area. It all makes for a very rich spread.

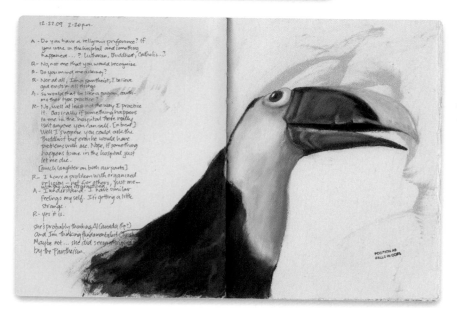

Sense of Volume
Roz Stendahl works with gouache frequently on a variety of papers in books she binds herself. This toucan shows the wonderful sense of volume you can get with this medium.

TRY THIS

GOUACHE ON TONED PAPER

Gouache is easy to use, but you need to be aware that it may dry darker than you expect. It's very nice on toned paper, though. I had a little journal that came with green paper, so I decided to play with it. Do your own toned-paper experiment with gouache.

1 I sketched my cat Rags on green paper and added the first touches of white. Then I began to shape the shadows with cool blues.

2 You can see I changed the size and shape of Rags's far ear before laying in the first layer of darker tones.

3 A small brush works well to build layers of suggested detail until the effect seems right.

Gouache Detail
Artist Sandy Williams revisited gouache after having difficulty with her vision. It was a very successful experiment—you can see she achieved a high degree of detail.

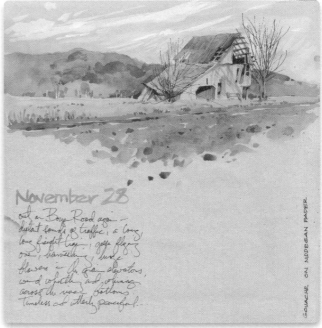

Opaque Clouds on Toned Paper
The opaque nature of gouache allowed me to suggest a pale blue sky and puffy white clouds, even though my paper was tan.

WATERCOLOR PENCIL TESTS

Like watercolors, watercolor pencils have had whole books devoted to their use—I wrote one of them. This medium isn't quite as simple as it might seem. It's not a just a matter of doing a drawing and then moistening it. You still need patience to allow the layers to dry in order to achieve the effects you want. Watercolor pencils are really handy for journal work, though, and highly portable. Watercolor crayons, another water-soluble medium, are a close cousin.

TRY THIS
ADD A TOUCH OF COLOR

Try out your watercolor pencils by adding a bit of color to a sketch. Go easy at first, using one to three colors. This is a good way to get your feet wet as well as your paper.

Soft Color
You can get soft, subtle effects, like this, or bolder ones, depending on what colors you use and how much water you add.

Value Added
An old, nearly dry technical pen captured the basic image. An Ultramarine watercolor pencil provided the values.

Color Added
Here I used a brush pen with India ink and a touch of watercolor pencil.

TRY THIS TEST AND LABEL

Put your watercolor pencils through the same tests as I did in these examples. Use primary colors only or test-drive your whole set. Be sure to label the results so you don't forget what pencil to pick when you want a specific result.

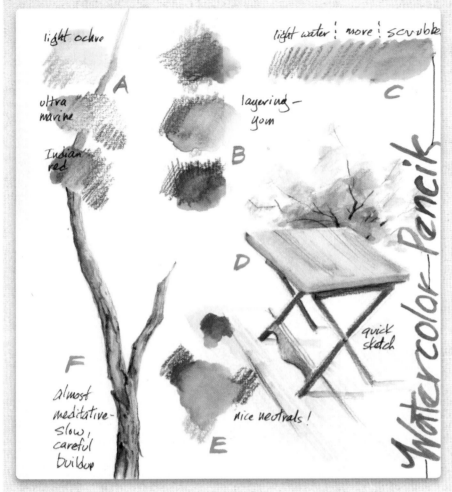

light ochre

ultra marine

Indian red

A

layering — yom

B

light water! more! scrubbed

C

D

quick sketch

F

almost meditative — slow, careful buildup

E

nice neutrals!

Watercolor Pencils

Test Your Colors
I like to explore a limited palette. I keep my journaling notes light, especially when out and about.

A. I started with Light Yellow Ochre, Ultramarine and Indian Red, both dry and wet. Note how they change color and value when moistened.

B. I layered these same colors to make secondaries.

C. Here, you can see different effects—from a quick brush of water on the left to more rubbed-in water in the middle to nearly scrubbed in water on the right, which lifts the stroke lines.

D. I used the same colors for this little sketch with the addition of black in the limbs.

E. When I mixed all three colors, I got a nice range of warm and cool neutrals. The smaller swatch above was done by lifting color directly from the pencil point with a wet brush.

F. I carefully built up the color and shape of this dead tree with my original three primaries plus black.

Test Your Paper
The paper you use with watercolor pencils makes a huge difference in your results. As much as I love folio paper, it's too soft for these tools, as are many inexpensive commercial journals. Notice the difference between the colors painted directly on my journal page and those painted on a bit of hard-finished, well-sized watercolor paper, which I glued in place at the lower center of the page.

COLLAGE TESTS

Many journalists add collage to their pages. Others use it almost exclusively, adding layer after layer. Because my journal entries are often created on the spot outdoors, I use less collage. It takes too long to dry. Still, collage is a rich, satisfying approach well worth exploring.

If you work with multiple layers, you may want to have several pages going at once because you'll need to allow one layer to dry completely before adding another. Any white glue will work; I usually use a PVA glue preferred by bookbinders, but some people swear by YES! Paste. It's archival, allows collaged elements to dry flat and won't tear the collaged element if you remove it. Glue sticks are handy, but the glue may lose its adhesion after a few years.

Let serendipity suggest what you add to your pages—a chocolate bar label, a restaurant matchbook cover, a postcard from a friend, that evocative tidbit from your fortune cookie—or collect a stash of elements to add to your journal later. I keep a whole drawer of ephemera, pieces which often end up in my more formal collages. The flatter ones sometimes find their way into my journals.

My only suggestion is to use things that really speak to you, if this is truly to be your personal diary. I like to use those things that spark a memory or emotion rather than a merely visual image.

Do be aware that if you glue in add-ons that are too thick, your book won't close. Some journal keepers get around this by cutting out a few pages to allow room for thicker ephemera. Just leave a little tag of a page near the gutter so it won't come loose from your book. Of course

Add Layers
This collage has many layers, which made the page almost as stiff as cardboard.

Cover Up
I didn't like how the sketch of my husband turned out, so I borrowed Fred Crowley's trick and pasted a bit of paper over my "mistake," then tried again!

Go Graphic
Jeanette Sclar has a wonderful graphic sense! She combined collage with her drawing to make a memorable tribute to dinner.

you may not mind a book that gets almost as fat as it is tall. If not, go for it!

Sometimes you don't want to paste down the original piece of ephemeral—or you may not have it. An antique indenture on parchment is hardly a candidate for casual collage, and you may not want to sacrifice that old, out-of-copyright book to cut up for the marvelous illustrations. If you have a computer, scanner and printer, you can always make copies for your collage pages. This adds immeasurably to your store of available and meaningful goodies.

Note that the printer you use does make a difference. Ink-jet printers with dye ink may give you images that smear when wet; pigment-based ink is much less likely to smear once it dries. Try using an ink-jet paper or spraying your image with UV digital spray before gluing, and be careful not to use too wet an application of glue or paste. If you can only print in black ink, remember that you can always print on color or printed paper, or paint over the image with watercolors.

TRY THIS
PLAN A COLLAGE

Sometimes as you collect ephemera, collages just seem to happen, but you may want to plan a collage up front. I wanted to do a demo for this book, and dinner out captured my imagination. Keep your eyes open for likely bits of paper ephemera to add to your own pages.

1 My husband and I were at our favorite Chinese buffet. I was too hungry to draw before I ate, so I did a quick sketch of my demolished shrimp plate, using an indigo colored pencil. I made mental notes of colors.

2 When I got home, I splashed in some bright watercolor. My husband had collected a business card for me; I left room for it at the bottom of the page. At the top of the page, I tried to reproduce the Chinese characters on the card.

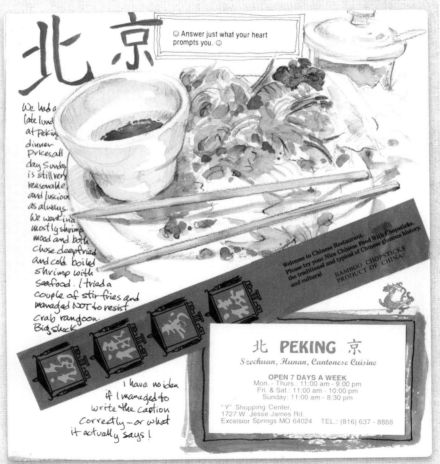

3 I'd saved the colorful paper envelope from my disposable chopsticks, too, along with the slip of paper from my fortune cookie. I moved things around until I was sure I liked the placement, then glued them in place. All in all, I had a bright page full of memories.

DESIGNING YOUR PAGES

My students are always interested in learning ways to design journal pages so that they have more impact, have a strong graphic element or hang together better. In other words, they want to create visually pleasing pages. People often ask me how I design my own pages, and I have to admit that sometimes it's a matter of evolution. I just keep adding things until I quit, either because it feels right or the page is full.

Sometimes I just do a sketch or a collection of them on a page and leave it at that. Creating a well-designed page involves practice as much as anything. Sometimes relationships seem to suggest themselves after I've "completed" a page, and I'll add a headline or a box or a circle to focus attention on some element or tie it together with other related images. Designing becomes almost instinctive. Sometimes just overlapping images is enough to create unity.

On the next few pages you'll see designs from a variety of journal keepers to inspire your imagination. Visualize your own art there. Try out a new format. Stretch your limits—you'll find they'll continue to expand.

Keep It Simple
A journal page may be a single sketch or study, with or without text or notes. That approach can be very clean and fresh.

Add Day by Day
Nina Johansson combined several mediums over a week's time (*vecka* is Swedish for *week*) to fill this delightful spread.

If I draw on the same page and keep to the same technique or some kind of theme for a whole week, I end up with something that looks very well thought-out, even though it wasn't.

—Nina Johansson

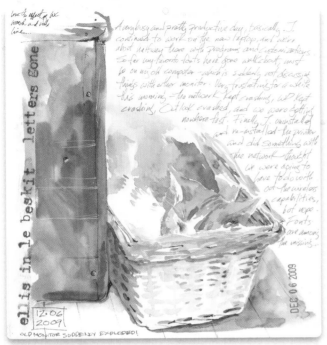

Rubber Stamp Words
I added a true journal entry to this page. A partial set of rubber stamps made the creatively-spelled caption at the left. Sometimes a bit of whimsy is a necessity!

Positioning Text

Text can add a lot to your pages, helping them to hang together, giving them a strong visual focus or simply letting your journal function as a diary. Use a text block with neat, rectangular edges or let your text follow your image or perhaps let the image appear to float on top of the writing. That last is a bit trickier—if it's a true journal entry, you want to be able to read the words later—but it can be done.

Some artists do the most wonderful calligraphy to complement their pages, weaving the words in and around the images.

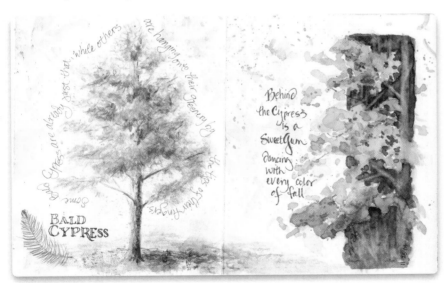

Wed Words to Images
Naturalist and artist Pam Johnson Brickell created this beautifully integrated journal spread, allowing one image to migrate over to the next page, using harmonious colors and letting calligraphy enhance the whole.

I feel I must concentrate as much on the lettering as on the artwork. For me, this means working in a controlled environment and practicing good posture. Usually I'll add calligraphic touches after the fact because, when sketching, I'm usually hunched over my sketchbook as I sit on a camp stool.

—Pam Johnson Brickell

Overlap for Integration
Ellen Burkett uses bold text to create a graphic spread. Bright colors and an arresting image remind me of ads and labels from the early twentieth century. Overlapping the words with the cat's body integrates the image.

Text for Balance

Text can also be used to balance the composition. Think of weight, value and color when considering this balance. Sometimes just a touch of the same color you used in your art provides a nice balance.

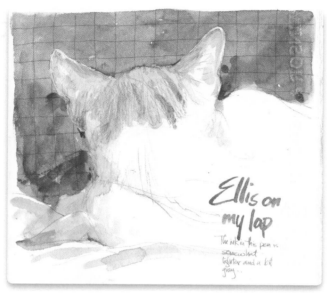

Use Text Color for Balance
My loose headline echoes the color of the graphed background.

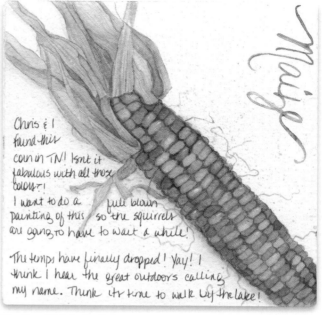

Use Text Weight for Balance
Laure Ferlita balanced a triangular text block with a simple headline to enhance her subtle diagonal watercolor of Indian corn.

Eye Path

As you compose your page, consider the path you want the eye to travel. This is a traditional compositional technique most often seen in finished paintings, but it works on journal pages, too.

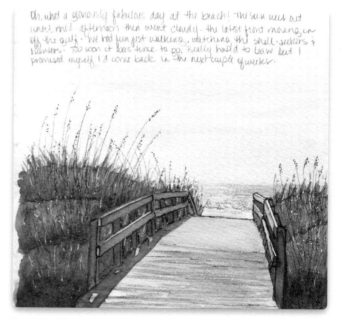

Lead the Eye
Laure Ferlita has used a simple but compelling layout for her journal page. The image occupies the bottom of the page and the walkway invites us right into this wonderful scene.

Border

I like borders on my pages. Using them is a personal decision that may be driven by the subject and your mood. Borders can help tie things together, call attention to a detail, or simply make a pleasing page.

Color Band Border
A simple band of color forms a side border while enlivening and integrating this journal page. The sunny yellow captures something of the mood of a day spent with my godchildren. I blotted it a bit to add textural interest.

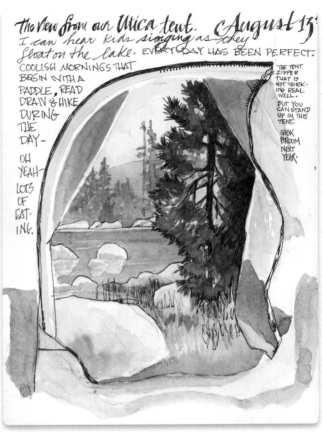

Doorway as Border
Gay Kraeger's border is formed by the edges of her tent doorway. This scene makes us feel we're right there in camp with her.

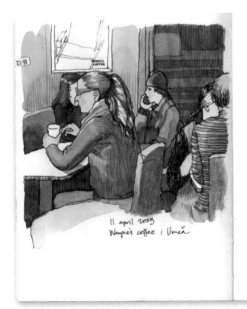

Contrasting Borders
Nina Johansson uses the white of the page to create borders on this spread. The dynamic diagonals on the right contrast with a vignetted image on the left. You get the feeling that the window view is what these café denizens would see if they just turned around.

Grid

Grids (as well as borders) give a journal page or spread a strong graphic feel and help to relate images to each other. Grids may be composed somewhat formally with regular squares and rectangles or less formally with asymetrical elements.

Double-Page Spread

Don't limit yourself to a single page. Try going right across the gutter to create a broad horizontal. This is especially appropriate for a landscape, seascape or other broad vista.

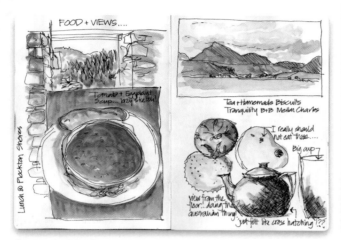

Asymetrical Grid
Liz Steele composed her grid with a variety of shapes. With the images together on this one spread, you see their relationships to each other.

Grid With Background Color
Jeanette Sclar's compositionuses background elements of different shapes and sizes.The background colors, related to the subjects of her drawings, intergrate her beautifully balanced page.

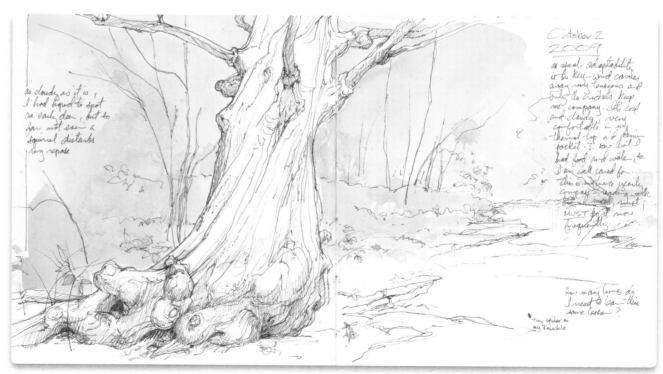

Write Over a Light Background
You can fill the whole spread with your art. Your notes or observations can overlap the images, as long as you keep the colors light enough, as I did here.

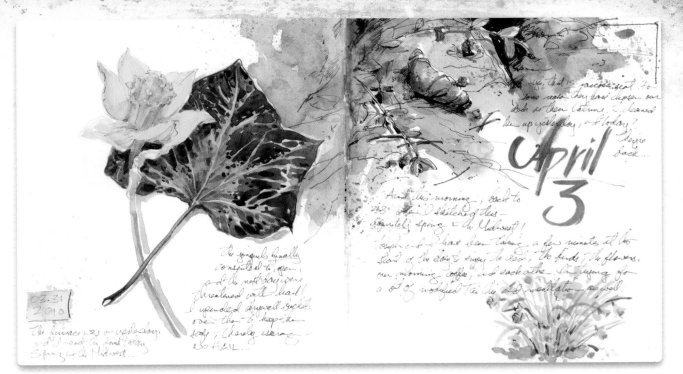

Several Days' Work
This two-page spread was done over several days, combining related images and color for unity. Sometimes I like to add a little date cartouche, as I did here, which provides a bit of balance. The bold headline makes a graphic statement.

TRY THIS

PLANNED AND EVOLVED PAGES

If you really want to plan a page, try creating a variety of small thumbnail sketches, each no larger than 2"x 3" (5cm x 8cm). Vary sizes, value, color and shapes for a pleasing effect. Then see what kind of a journal page you can create using the sketches you prefer.

You can also let a page evolve. Just keep adding sketches or studies, and when your page is full, consider how you might finish it. Experiment with borders, backgrounds, wide bands of color and bits of text. Don't like the final effect? No problem. It's your journal—learn from it!

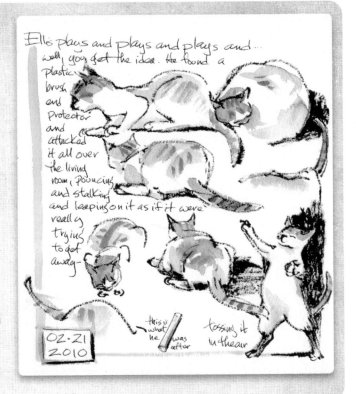

Let the Subject Evolve
I did lots of very fast little gesture sketches of my cat Ellis. When the ink was dry, I added the suggestion of color, a matching line down the side, the date and some text.

Consider the Possibilities

I've mentioned only a few of the possible design ideas for journal pages, of course. Leaf through this book to find more that appeal to you. Ask yourself what it is you like about certain pages—then try the ideas in your own work.

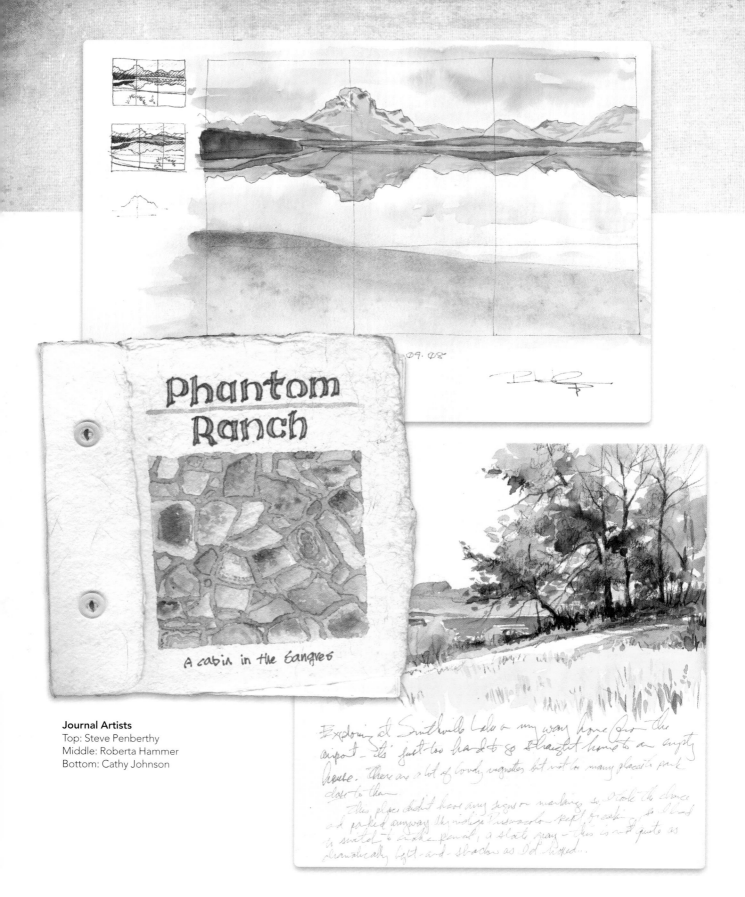

Journal Artists
Top: Steve Penberthy
Middle: Roberta Hammer
Bottom: Cathy Johnson

EXPLORING JOURNALS

You've got a blank book in hand; you've collected tools and materials and tried them on for size; you've considered how and why you want to keep an artist's journal. Now let's take a better look at some of the kinds of journals you might keep, what inspires you, and what you might actually put on your pages. This is where things get really interesting.

There are almost as many types of journals as there are journal keepers. What works for *you* is what's important, not what anyone else is doing. There are daily journals—like a diary or book of days—and travel journals to record a special trip. You may like planning journals for showing the evolution of your art from thumbnails to sketches and detail studies to the finished piece. Theater and costume designers often use their journals in this way, including photos, sketches and swatches of fabric. Journals can help you explore and preserve memories, almost like a scrapbook—and, of course, you can paste in photos or other memorabilia, if you choose. Nature journals are increasingly popular, and they're a great place to discover more about your environment. You may even discover a previously unknown insect or plant. Some people use their journals to spark creativity, record dreams and encourage the imagination. You may wish to use your journal to record your spiritual journey. Setting aside a journal to record a special theme can be fun.

In the following pages, we'll take a closer look at different types of journals. Choosing which type you want to keep is up to you!

DAILY JOURNAL

The most common journaling form is the daily journal. As the title of Danny Gregory's inspiring published journal puts it, *Everyday Matters*.

Take notes, make plans, record your day or simply draw something every day for practice. Keep it simple with a single quick sketch or do a montage that expresses the day for you. Try an overview at the end of the day, even if it's just a thumbnail sketch to capture what you remember most clearly. Or keep adding bits and pieces all day long or over a period of time. There are no rules.

You'll want to date your journal in the front, at least with the year, but for the daily format you'll also want to date each entry. A simple day/date/year indication is fine or just the day or the month and day. Currently I'm playing with a little cartouche—a small rectangle containing the month, day and year, reminiscent of rectangles containing a monarch's name on Egyptian monuments. A page can certainly contain more than one date, if you wish. I've gone back to a single page and added more and more until I ran out of room, dating each addition or not.

Many people like to standardize their entries with more than the date. How about an overview of the weather, your plans for the day or a reference to a holiday or worldwide

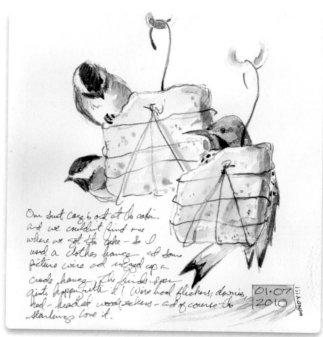

Date Cartouche
I combined a date cartouche with a suggestion of how windy this winter day was. My feeder birds really appreciated the suet.

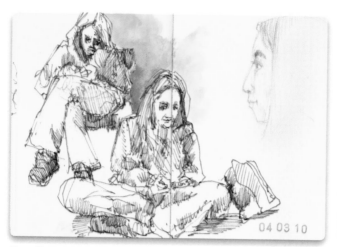

Date Stamp
Fred Crowley often uses a date stamp, unifying the colors or going wild with two or more reiterations on the same page in different colors. The stamp adds a wonderful graphic element.

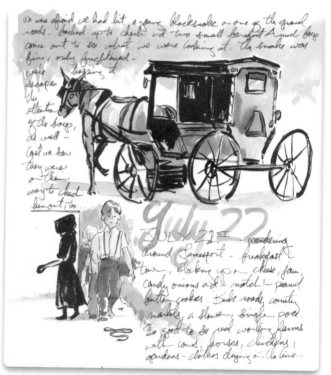

Bold Date
You can let your notes go right over a big, bright date that picks up the other colors on the page for unity.

event that falls on that day? Add a tiny sketch of the phase of the moon if you like.

A daily journal needn't be mundane. As you pay attention to the beauty, humor and challenges in each day, you'll add the bits and pieces that capture your interest. You'll notice tiny miracles or ask the eternal questions. You'll laugh out loud, even when no one is around. Those moments will live in your memory as well as your journal pages.

Since we are talking about daily journals, though, remember you can put anything and everything there— your to-do list, a grocery list, appointments, notes, reminders, what have you. Paste in your ticket stubs, invitations, dried flowers, baggage claim slips, postcards or other mementos. The item doesn't even have to be artistic—just a record of your day.

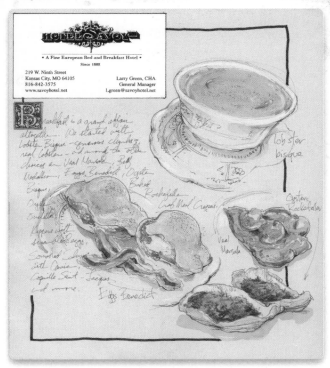

Add Ephemera
I quickly sketched my breakfast at the wonderful old Savoy Hotel in downtown Kansas City. I added color later. Then I pasted on the manager's business card and an illuminated letter "B" that I'd snipped from their menu.

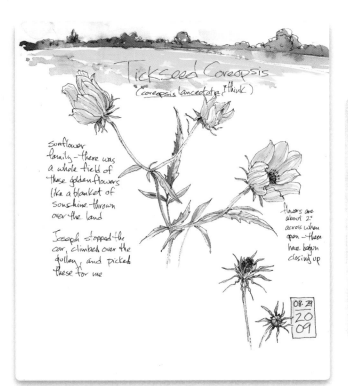

Set Memory Triggers
This journal page reminds me just where and when I found these gorgeous, butter-yellow flowers.

TRY THIS

DESCRIBE YOUR DAY

Create an entry for a daily journal. Include whatever you want to describe your day. Fill a whole page, do a montage or, if time is short, just do a thumbnail sketch. You can draw how you feel rather than what you see. If a memory bubbles up, you can sketch it and make a note about what made you remember the occasion. You can choose one particular thing that catches your eye or encapsulates your day. Don't make this a chore. Just draw something and write down why you drew it.

TRAVEL JOURNAL

The travel journal is one of my favorites. Years ago, an old friend and her husband traveled all over the world with an Elderhostel group, keeping the most fantastic journals of their travels. I loved looking through her simple, bright sketches, notes, and pages full of photos, bus passes, bits of brochures and more. They made me feel as if I'd been right there with her.

Sketch anything and everything you see on your travels—landscapes, shops, museums, street kiosks, restaurants, fountains, skyscrapers, seashells, landmarks, clothing, wildflowers, people, animals, boats, trains, airports, birds, ocean piers—you'll really capture something of the essence and "bring it back alive," as they say. Combine several of these images on a page. I believe when we take the time to journal on our travels, we experience more deeply and remember more than when we fly by, even with a camera to record what we see.

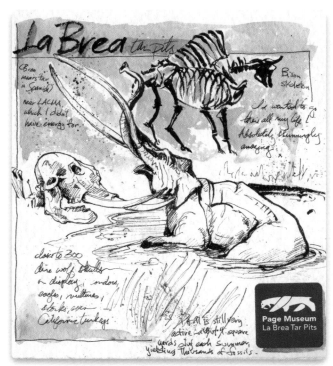

Ink at the Page Museum
I'd wanted to see the LaBrea Tar Pits ever since I was a kid. I was able to make ink sketches at the Page Museum there. Later I added a tar-colored watercolor wash.

TIP

CHECK OUT PUBLISHED TRAVEL JOURNALS

There are many wonderful books, both old and new, that explore travel journaling. Check out works by William Clark, Fabrice Moireau, John White, Graham Byfield, Diana Hollingsworth Gessler and the marvelous David Gentleman. They'll transport you around the globe in a heartbeat, allowing you to see the world through a fellow artist's eyes and inspiring you to keep a travel journal of your own. Marie Le Glatin Keis wrote *The Art of Travel With a Sketchbook*; you may find her suggestions helpful.

Travel Ledger
Lapin has a wonderful book out with lined pages that suggests a vintage ledger casually picked up and pressed into service as a travel journal. That's much the way Lapin started his journaling.

I use my books to draw people I meet, record my travels every day and make sketches of the cities I visit—more or less in that order. That's how I record my surroundings, and all my sketchbooks are my personal archives.

—Lapin

Museums

Museums can capture the essence of your travels. Be advised, though, you may not be able to work with your favorite materials. Some museums insist on pencil only—no ink pens and certainly no watercolors or other paints. Some art museums will let you sit and work from the paintings on their walls; some will not. Sketching is a wonderful way to experience masterpieces. Just be sure you find out ahead of time what you're permitted to do.

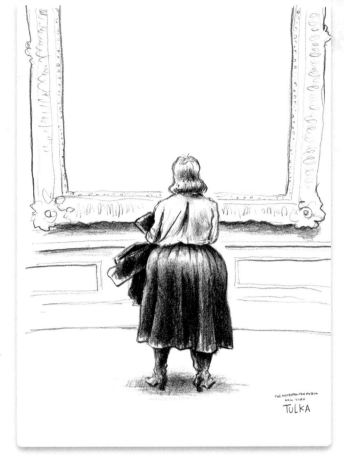

One Pencil at the Met
Rick Tulka used a very simple approach—one pencil, one image—to capture this woman, rapt in the inspection of a large painting at the Metropolitan Museum of Art in New York City. We don't know what she's looking at, and it doesn't matter—the image catches the reality of the experience.

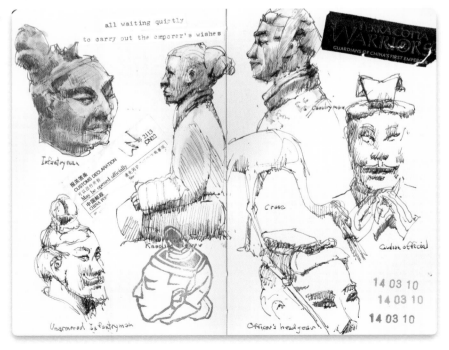

Terracotta Warriors in D.C.
Fred Crowley drew sketches of a number of the terracotta warriors originally found in Emperor Qin Shi Huang's mausoleum in Xi'an, China. He added a bit of collage in the form of text, a label for the warriors and a corner of a customs declaration, along with an image of a warrior's head—printed with a handmade rubber stamp—and a date stamp. This spread captures much of the scope and mystery of this astounding collection, a portion of which was on display in Washington, D.C.

Quick and Simple

Time is of the essence when you travel, unless you have the luxury of uninterrupted hours alone to work at your own pace—or a truly understanding traveling companion. Other people and their interests and needs must be taken into consideration, and it's a rare trip when you're able to sketch till you're happily and completely done with the image at hand. Also, light changes, as does the weather.

Just get the basics down, if that's all there's time for. You can leave it at that (and believe me, such a sketch will still act as a trigger to memory) or add color or detail later, based on your notes. You'll learn to train your color memory.

Sometimes I prefer the simplified or more subtle form and color I get by adding color later rather than laboriously matching hue and value on the spot. I may choose to go with an impression of the mood rather than local color. Oddly, with this approach, your journal entry may ring more true, not less.

To train yourself to work fast, avoid getting hung up on details. Work from large to small and try to stop before niggling sets in. Some of my best, most evocative sketches are of that type. K.I.S.S. (keep it simple, silly!) is more than a motto. It's a practical piece of advice that can work when you're journaling on the move.

Lead-Free Watercolor
When you need to work quickly, sometimes going lead free offers just the fresh approach you want. This journal entry was done in watercolor with no preliminary sketching. It was very cold on the summit near the Mount Wilson Observatory in California, and I was working fast.

Pen Now, Colored Pencil Later
Jennifer Lawson used a single red technical pen for this small sketch of the ferry at Casco Bay, Maine, and Bug Light, nearby. She added colored pencil later, giving a fresh nautical look to the scene.

Extreme Color
Catriona Andrews let the colors soar on this page. The result is much more exciting than it might have been if she'd reproduced the colors faithfully.

I used only colored inks with a dip pen and brush. Because you can't get proper colors from inks, I embellished I just wanted to experiment and get the feeling of the view rather than an actual representation.

—Catriona Andrews

TRY THIS
ABSTRACT THE SCENE

Now is a good time to try abstracting what you see. Look for basic shapes and note how they overlap one another. Think of the scene as a stage set. Notice what's closest to you and what's in the middle ground and background. Remember that things in the distance often look lighter, simpler and cooler. Let your shapes or lines overlap freely or erase where something is in front of the other.

Landscapes lend themselves well to this kind of abstraction. The layers of hills suggest distance, and trees in theforeground can be simply drawn to lend depth to your sketch. It's amazing how few lines you need. If you have more time you can go back in and add detail.

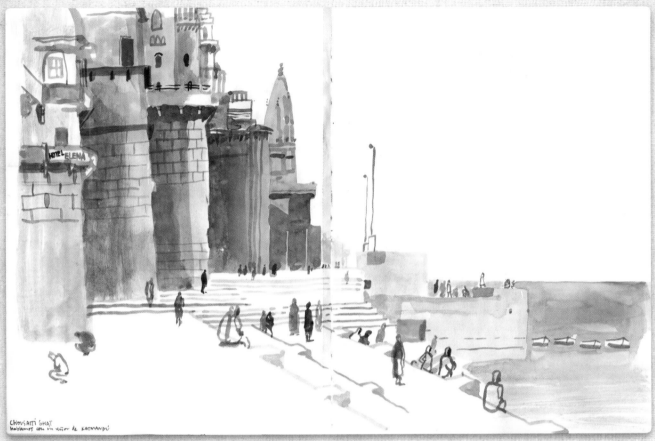

CHOUSATTI GHAT
habitant con un vistor de KATMANDU

Abstract the Shapes With Water Brush
Enrique Flores abstracts shapes and forms to stunning effect, drawing with his brush alone in this sketch of Benares, India. Enrique uses water brushes, often filled with thinned paint, so he doesn't have to carry a box of watercolors and a separate water supply.

Correcting mistakes in watercolor is always difficult, especially because I never have pencil lines to follow. But I love the speed of the medium and also the dizziness of working with no safety net.

—Enrique Flores

Travel Light

Try not to carry everything but the kitchen sink. What seems light enough at home gains weight exponentially as you rush from gate to gate at the airport or hike up a mountain. I actually weigh each of my supplies before leaving home, choosing the lightest, most basic items to carry with me. Prune out what you don't need or never use.

Every time I go on a trip, I simplify my gear a bit more. Sure, I'd like a set of colored pencils and watercolor crayons along with my pens and pencils and watercolors, but really! You can usually find a source of water—or use tea, coffee, wine, saliva, whatever. A sharp stick or the sharpened end of a watercolor brush can double for an ink pen. Just dip the brush end into your watercolor and paint with it, or use it to scratch lines into a wet wash.

When I travel, I usually carry a mechanical pencil with a good eraser, two or three technical ink pens (or a favorite fountain pen filled with waterproof Platinum Carbon ink) and a couple of colored pencils. In addition, I always have a small, light folding palette or a watercolor box made from an Altoids tin and a small selection of brushes and water brushes. Those items, along with my journal, are really all I need no matter where I go.

Pay attention to Details

Add informative tidbits to your page—things like the name and address of your hotel, cabin or bed and breakfast; your room number or name; whether you liked the view or the amenities; and what you had for meals.

Sketch details, too—what you see out the window, decorative appointments in the room—whatever you wish. These details really bring back the memories.

A Brush and a Stick
This journal entry was done with one flat watercolor brush and a sharp stick.

Just a Pen
Art supplies do drag you down when you trek through outdoor historic sites or museums. In San Juan, Puerto Rico, I had just my journal and a sepia pen, and they were plenty to capture the feeling of the old Spanish mission, especially on toned paper.

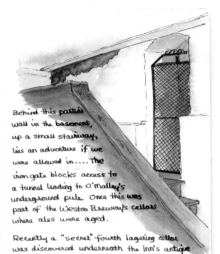

Good FRIENDS & CONVERSATION Round the INGLENOOK

Kate & Joseph were able to meet us for dinner at O'Malley's "America Bowman", a great restaurant named for a young woman born on 4 July and an early settler in Weston, MO.

This wonderful stove had inserts of soapstone; Kate said it made a great spot for cats in winter.

Behind this partial wall in the basement, up a small stairway, lies an adventure if we were allowed in..... The iron gate blocks access to a tunnel leading to O'Malley's underground pub. Once this was part of the Weston Brewery's cellars where ales were aged.

Recently a "secret" fourth lagering cellar was discovered underneath the Inn's antique shop & dining room.

Pub Details
Vicky Williamson caught the flavor of this Irish-themed room in an old bed-and-breakfast converted from a brewery's storage. The stairway on the right now leads to an underground Irish pub. Ink and watercolor worked well here.

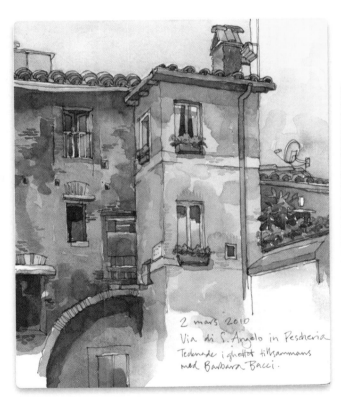

2 mars 2010
Via di S. Angelo in Pescheria
Tedernde i ghettot tillsammans med Barbara Bacci.

Essence of Rome
Look for quiet neighborhoods or off-the-beaten-path views that capture something special of your locale, as Nina Johannson did here when she visited Rome. It's not the Vatican, not the Colosseum, but definitely *Roma*!

Plane Details
Here I recorded our airport gate, flight number, airline, the location where the Jeep was parked and the date. Then I started to sketch. One of my notes remarked on the lovely colors of the sunrise, so I added those colors and showed light on the faces nearest the window.

TRY THIS

RECORD THE DETAILS

Create a travel page with lots of written details—your destination, weather, time, date, season, whether the people speak your language, snatches of overheard conversations, exotic scents and sounds.

Then create a page with a detailed sketch—a relic in a museum, a grinning gargoyle, an unfamiliar wildflower. Perhaps combine the two types of detail—visual and written—on one page.

Adjust Your Palette

Let the landscape and climate speak to you in terms of color. Consider switching out colors in your paint box to fit the season or locale.

Record Detail in Word and Art
Fred Crowley focused on details that caught his eye during his visit to an exhibition of Egyptian artifacts.

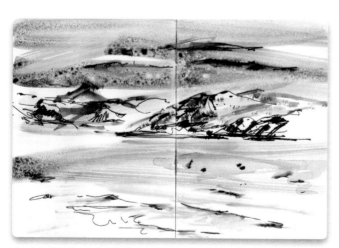

Cool Colors for a Cool Climate
Icy colors dominate Laura Frankstone's sketch of Norway's frigid winter sea.

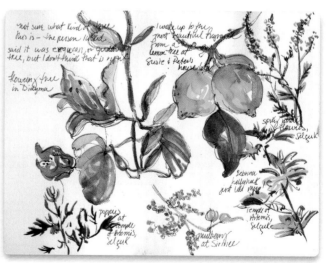

Warm Colors for a Warm Climate
When Laura Frankstone went to Turkey during its warm season, she knew she'd need a selection of warm colors.

Maps

Draw or paint maps on your journal pages. Include the whole area or zero in on the details of a garden, historic site or even a single room. Of course you can also paste in or trace a map from a brochure.

Neighborhood Map
Liz Steel sketched details of her dinner and an intimate map of the restaurant's location.

City Map
Here you see the aerial sweep of Oran, Algeria, by Enrique Flores. You almost feel as if you're in a plane about to land in this exotic place.

Virtual Travel

If you can't travel, try looking at your own town with new eyes, as Vivian Swift did in her book, *When Wanderers Cease to Roam*. When I started organizing sketch crawls in my town, I saw details I'd never noticed before, and I began to appreciate the town and its history far more.

Another option is to investigate online virtual travel. Laure Ferlita offers online art classes called Imaginary Trips that are based on this idea. If her students' blogs are any indication, virtual travel with Laure is almost like being there. Her classes have visited England, Paris and the beach without having to pack, get a passport or go through airport security.

Other artists use Google street maps to help them travel the world in their journals, and then they share their virtual trips online.

This class demo represents a very Parisian afternoon activity. It's important for the virtual traveler to learn to draw— capturing just enough detail without getting bogged down.
—Laure Ferlita

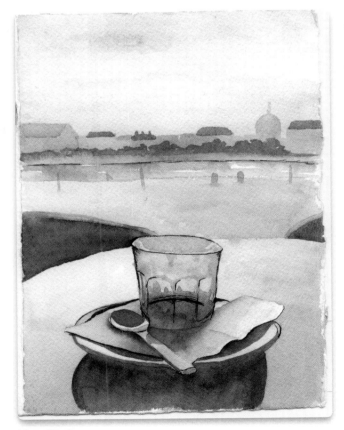

Virtual Paris
This compelling yet serene image by Laure Ferlita captures the relaxed feeling of a late brunch in a Paris café.

MEMORY JOURNAL

Art journaling preserves memories like nothing else—even better than a scrapbook—because drawing makes the memories so personal. Sketching is a direct heart-mind-hand response that immediately puts you in touch in ways that photos and scrapbooking just can't.

So much of life is fleeting. Infants become toddlers and then graduate before you know it. Kittens (and gardens) grow fast. Bouquets wilt. Life is change, but as long as we remember, we can revisit past times again and again. First occasions can only be first once, but if you sketch them in your journal they'll live in your memory forever.

Our family members and friends often benefit from our journal keeping, enjoying our memories, vicariously traveling with us or celebrating life's small moments.

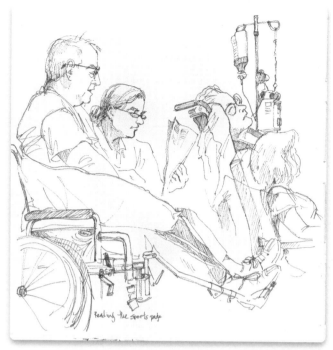

Shared Memory
My husband and his dad, Chet, share a quiet time on a recent trip to California. Chet had experienced a stroke, but he still communicated with laughter and smiles and a few well-chosen words. I sent Chet a print of this sketch, which he treasures. My journal is far-reaching.

Another Goodbye
I seemed to document a lot of departures before my husband retired. This page reminds me of one of the last times he traveled alone.

Solace for Loneliness
Concentrating on capturing the beauty of this rose helped me feel less lonely when my husband was away on travels.

After my great aunt died, I became aware of some fascinating objects that had belonged to her and my great grandfather's family, including World War I medals and badges, photographs and letters. I'd been researching the family tree and got the idea of visually documenting these family possessions, drawing each object and then adding some commentary about its history. The next stage is to add notes about the person and time of his or her life. In this way I hope to show my family members as real people and to record a part of my family history that would otherwise be lost.

—Alissa Duke

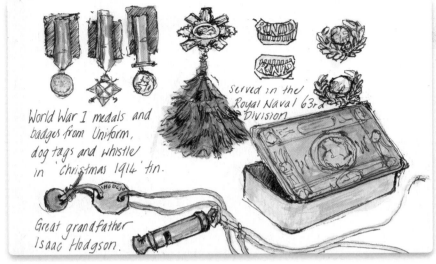

World War I medals and badges from Uniform, dog tags and whistle in 'Christmas 1914' tin.

served in the Royal Naval 63rd Division

Great grandfather Isaac Hodgson.

Memory Project
Alissa Duke has taken it upon herself to sketch her family's tiny treasures.

TRY THIS

SKETCH FAMILY MEMENTOS

If you're fortunate enough to have family treasures, sketch them, no matter how simple or ordinary they may seem. All are worthy of your attention; they embody your personal history.

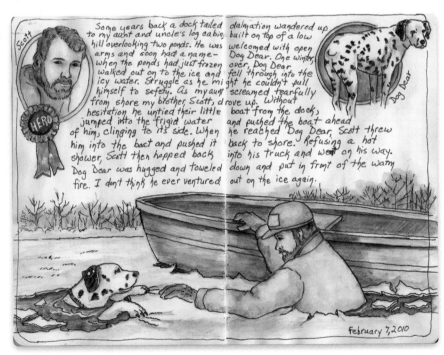

Some years back a dock tailed dalmation wandered up to my aunt and uncle's log cabin built on top of a low hill overlooking two ponds. He was welcomed with open arms and soon had a name—Dog Dear. One winter, when the ponds had just frozen over, Dog Dear walked out on to the ice and fell through into the icy water. Struggle as he might he couldn't pull himself to safety. As my aunt screamed tearfully from shore my brother, Scott, drove up. Without hesitation he untied their little boat from the dock, jumped into the frigid water and pushed the boat ahead of him, clinging to its side. When he reached Dog Dear, Scott threw him into the boat and pushed it back to shore. Refusing a hot shower, Scott then hopped back into his truck and went on his way. Dog Dear was hugged and toweled down and put in front of the warm fire. I don't think he ever ventured out on the ice again.

February 7, 2010

The Great Rescue Story
Sandy Williams recorded an amazing story of her brother's rescue of their aunt and uncle's dog.

My journal has become a kind of partner in my life now. My personal journal crystallizes feelings, events and memories. It's become a unifying element in my family—they love to read it and often say they "didn't know that" about some particular item I've recorded. Some of the stories that my brothers and sisters and I have grown up with might never have been related to the next generation, who now sees "our" journal as a family record.

—Sandy Williams

I told my sister that I'd sketched Grandma Kelley's necklace, and she remembered that she used to love holding that necklace up to the light, seeing the world glowing through the faceted amber stone. I used to do the same thing! My journaling enabled us to share those memories.

Memory journals don't just record the past, they can also record the present, which will become tomorrow's memories. We all know how quickly kids grow up. Sketch them in special activities and add their funny or insightful sayings. This will become a treasure to you and also to them.

grandmother Kelley's necklace

it was only glass, brass, and mis-shapen freshwater pearls, but we all thought it was fit for the Queen of Faerie

Lost but Not Forgotten
This old glass, brass, and freshwater pearl necklace belonged to my grandmother Kelley and then to the women of the family. We passed it back and forth for weddings, renewals of vows and so on for years until it was finally lost. Fortunately, the last time I was in possession of it, I'd had it photographed and sketched it in my journal.

Crowley Kremer paints seemed to work for this old toy...

one eye is half gone, doesn't look as

May 31 – I've had Rocky forever, too–named after my favorite beagle – I was raised by beagles – my older sis Yvonne reupholstered him for me, repeatedly, as he got too filthy!

Favorite Toy
My old stuffed blue beagle reminds me of so much I might otherwise have forgotten over the decades. My dad used to raise beagles, and I named this chubby fellow after my favorite, Rocky. I dragged him everywhere with me as a kid, and he got so filthy, my older sister "reupholstered" him for me several times.

TRY THIS
SKETCH A PERSONAL TREASURE

Everyone has a personal treasure—a gift, a childhood toy, that first baseball glove. Sketch yours in your journal. Let it speak to you. Recall details, and make note of them. I inherited a really ghastly black ceramic panther with green rhinestone eyes that my dad just loved. No one else wanted it! It lived on his dresser as far back as I can remember—one of these days I'm going to have to sketch that!

We have never found an animal that Mikaela did not love. Though shy around people, she has no fear of animals no matter size or wildness. I think she would take them all home.

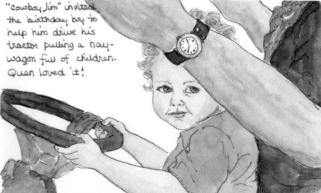

"Cowboy Jim" invited the birthday boy to help him drive his tractor pulling a hay-wagon full of children. Quan loved it!

The Grands
Vicky Williamson preserves special moments with her grandchildren.

TRY THESE

FOUR APPROACHES TO MEMORY JOURNALING

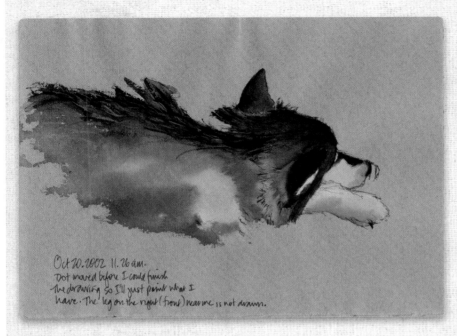

Oct 20, 2002 11:26 am.
Dot moved before I could finish
the drawing so I'll just print what I
have. The leg on the right (front) near me is not drawn.

Day by Day With Dot
Roz Stendahl decided to practice her journaling skills every day by drawing her dog, Dot. Besides giving her the opportunity to use all kinds of mediums and surfaces (this sketch is gouache on toned paper), the project became a way to explore the close, loving relationship between her and Dot. You can see Roz's *Daily Dots* journals at rozworks.com.

TAKE ON A PROJECT

Consider an ongoing project, like a family memory book, a record of all the houses you ever lived in or a collection of family recipes. Make them simple or more complex, whatever you can live with, but try to choose a project you care about. You're more likely to keep it up that way!

MAP YOUR FAMILY'S MOVES

Draw a simple map of your family's migration from country to country or town to town. Decorate it, as map makers used to do, with related images. Use a printed map to trace the countries or states or just roughly suggest seas, land masses and rivers (no one's going to use this map for navigation).

On a map of my family's migration, I could include Ireland, Scotland, England, the coast of Virginia, cabins in North Carolina and wagons through Tennessee, Kentucky, Illinois and finally Missouri, where most of us settled a century ago. There's a lot of rich imagery in your family journeying that can make you acutely aware of your history.

RETURN HOME

Draw your childhood home. Use simple geometric forms, if you wish, with lollipop trees and a big round sun—as if you were still the child that lived there. I guarantee this will kickstart your memories. Mark your favorite places—where you felt safe and why, or where your playhouse was (mine was under the front porch). Write about why these places were special to you.

GIVE YOUR MEMORY A WORKOUT

Try sketching either something long past or some scene such as a sunset or landscape that you viewed fleetingly from a moving vehicle. Choose something that sticks in your memory and then see if you can sketch it quickly. Ask yourself questions to fix the image in your mind or refresh your memory. Close your eyes and recall as much as you can. Add more details as you remember them. In this way, you'll train yourself to notice more, observe more accurately and remember more clearly.

NATURE JOURNAL

Study nature through your journal—it's one of the best tools you have, engaging hands, eyes, mind and heart. You'll stop, ask yourself questions and notice things you never used to pay attention to before you took the time to sketch them. You'll become almost like a child again, nose to nose with nature's small wonders. This has always been one of my favorite forms of journaling, so much so that I started a group blog, Sketching in Nature (naturesketchers. blogspot.com), with some truly wonderful observers of the natural world.

Be sure to include the date, weather and time of day in your journal notes or header, plus any other observations, such as sights, sounds, smells or interactions between animals.

CATCH THE DETAIL **TIP**

Let your sketches provide your own field guide illustrations. If you've observed well and made good notes (Are the leaves alternate or opposite? What is the animal doing and at what time of day? What kind of markings does that butterfly have?), you'll be able to identify your discoveries—or find someone who can.

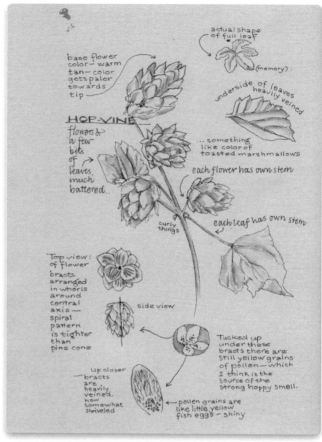

Botanical Sketch
Hannah Hinchman closely observed and carefully drew this hops plant and made salient notes of her observations.

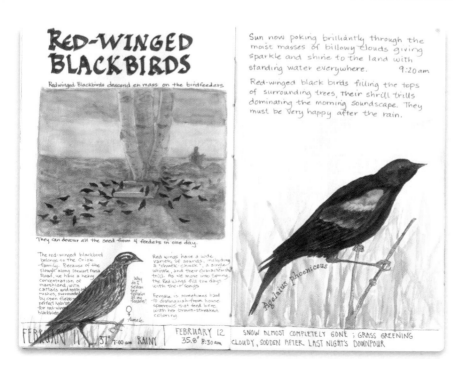

Personal Field Guide
Maria Hodkins included sketches of male and female red-winged blackbirds and the birds feeding on the ground. She also noted what they were doing, the date, weather, temperature and more.

Discover Your Own Backyard

A nature journal doesn't have to involve a safari to an exotic, isolated locale. Find nature in your local park, on the windy ledges of a skyscraper, in the cracks of a city sidewalk or in your own backyard. A birdfeeder on your balcony or porch provides endless hours of nature observation. I've drawn the tiny ants that find shelter in my kitchen in the winter, the luna moth that clung to my kitchen window and the lightning bug that crawled into my house under the porch screen. It's humbling and immeasurably enriching to realize how many life forms share the planet with us.

To really learn from your sketches, take plenty of notes. Record the season and location. Draw as accurately as you can. If you're sketching a bird or animal, note its behavior and the time you observed it. Some animals are nocturnal, and some are most active at dawn or dusk.

If you're sketching a flower, write down where it grows and whether that place is shady, sunny, moist or dry. All these things will help you identify the flower later. Invest in a good field guide, visit your local library, ask an expert in the field or Google till you find the answer. There are even online groups (www.Flickr.com, for instance) that will help you identify birds, wildflowers and more.

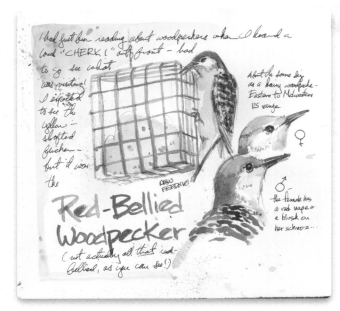

Feeder Action
I put out a new suet feeder and found at least four kinds of wood-peckers appreciated our offering right here in town—along with starlings, juncos, chickadees, cardinals, titmice, finches and more.

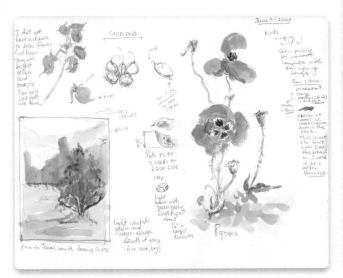

Flower and Habitat
Nina Khashchina did quick, detailed studies of poppies and the seedpods of a plant whose flowers she hadn't had time to draw while it was blooming. The small habitat sketch makes a charming and informative page, arousing curiosity.

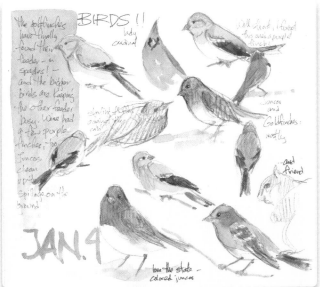

Fast Work
I did lightning-fast sketches of the birds at our feeder one winter day. They took form as I added color.

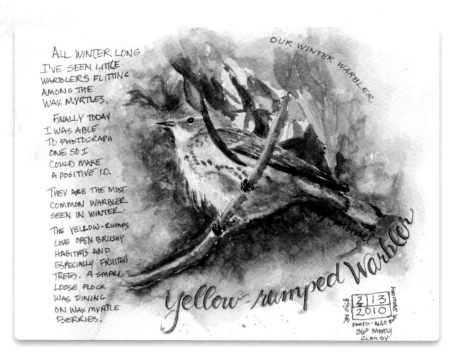

ALL WINTER LONG
I'VE SEEN LITTLE
WARBLERS FLITTING
AMONG THE
WAX MYRTLES.

FINALLY TODAY
I WAS ABLE
TO PHOTOGRAPH
ONE SO I
COULD MAKE
A POSITIVE I.D.

THEY ARE THE MOST
COMMON WARBLER
SEEN IN WINTER.

THE YELLOW-RUMPS
LOVE OPEN BRUSHY
HABITATS AND
ESPECIALLY FRUITED
TREES. A SMALL
LOOSE FLOCK
WAS DINING
ON WAX MYRTLE
BERRIES.

OUR WINTER WARBLER

Yellow-rumped Warbler

"Shoot" and Sketch

Pam Johnson Brickell lives in the southern United States and sees warblers all winter. She was finally able to get a photo so she could make a positive identification of this fellow and capture him in her journal.

Take Your Time With Plants

Plants and wildflowers are wonderful to work with because they stay put! They're not shy, so you can take as much time as you like. I saw this jack-in-the-pulpit in my own backyard jungle. It will later develop red seeds. Use as much or as little color as you like. I like the partially finished effect I achieved with a dark green technical pen and watercolor. The sketch invites viewers to complete the color in their imaginations.

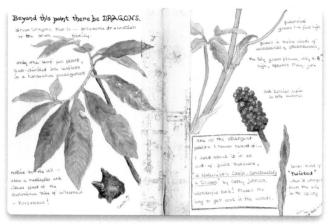

Beyond this point there be DRAGONS.

Learning Tool

Vicky Williamson used her journal to learn all about green dragons, a close relative of the jack-in-the-pulpit.

Make Habitat Sketches

A small (or large) habitat sketch on the same page as a sketch of a plant or animal tells you a great deal about the ecosystem you've encountered. For example, the simplest suggestion of the scenery can tell whether a flower grows in full sun or in shade. Dating your sketch tells you its growing season so you'll know where and when to look for the bloom in future years.

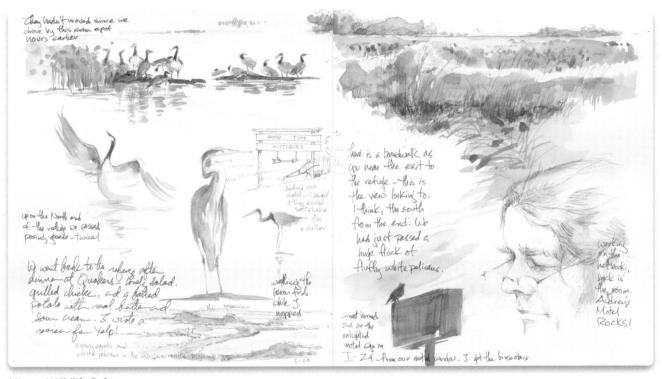

Missouri Wildlife Refuge

I spent a weekend at Squaw Creek National Wildlife Refuge in Missiouri and used a variety of media to sketch everything I encountered, including the owl that perched on the motel sign by the highway and my husband working in the blue glow of his computer back in our room.

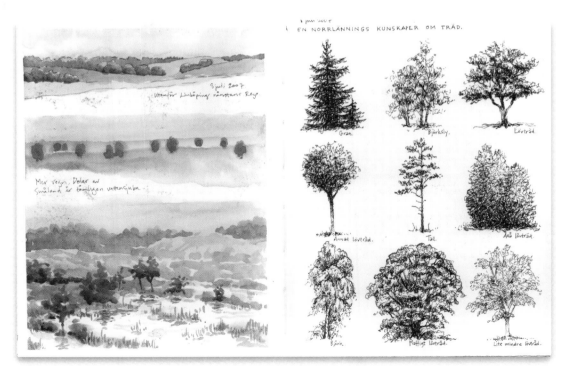

Trees of Sweden

Nina Johansson made her own field guide of trees in a specific area in Sweden, and included three small habitat landscapes on the facing page.

Use Whatever Means You Have

Sketch any wildlife you see, any way you can manage it, short of Audubon's method of shooting the poor creatures first (alas, not with a camera).

You may come across a baby mammal or bird in the wild, but don't pick it up unless you know it's been injured or orphaned. Do as many quick sketches as you can without frightening the creature. I found a tiny rabbit near my driveway once. He didn't move, so I sat on the ground next to him and sketched him from several vantage points, then went away and left him in peace. (I'm convinced his mother found him.)

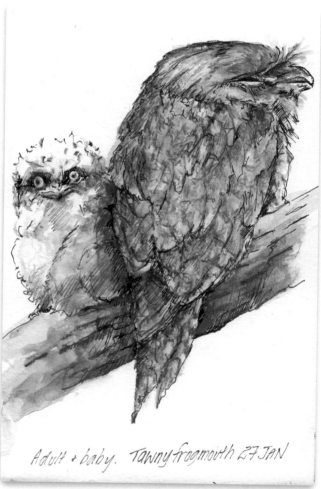

Adult + baby. Tawny frogmouth 27 JAN

Go to a Museum
Alissa Duke visited a natural history museum to get a closer look at these nocturnal Australian birds and to sketch their distinctive features. Often mistaken for an owl, the tawny frogmouth is actually distantly related to the whippoorwill.

TRYTHIS

QUICK GESTURE SKETCH

Practice very quick gesture sketches of any wild animal you see. If there's no time even for that, do a memory sketch. Birds and mammals are generally shy and spook easily, so all you'll have time for is something very loose. You can always refine it later.

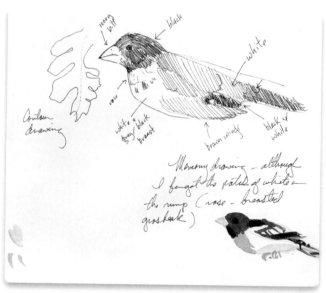

Draw From Memory
I saw this bird for only a few moments but sketched as much as I could remember and made notes about its color. That let me identify it later as rose-breasted grosbeak.

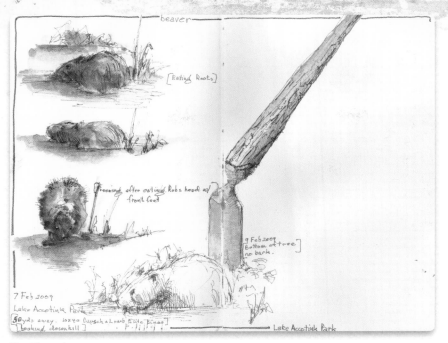

beaver

[Eating Roots]

[Grooming after eating. Rubs head w/ front feet]

9 Feb 2009
Bottom of tree
no bark.

7 Feb 2009
Lake Accotink Park
[50 yds away. 10x40 Bausch & Lomb Elite Binos]
[Lookout, Accomink]

← Lake Accotink Park

Use Binoculars

Fred Crowley observed beavers at Lake Accotink Park in Northern Virginia. Getting close to these large aquatic mammals is difficult because they're quite shy. They slap the water with those big flat tails to warn other beavers, then dive. So Crowley used binoculars to "get close."

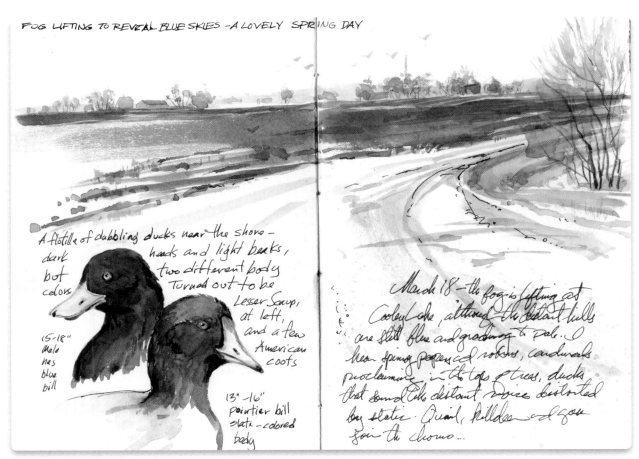

FOG LIFTING TO REVEAL BLUE SKIES — A LOVELY SPRING DAY

A flotilla of dabbling ducks near the shore — dark but colors, heads and light beaks, two different body Turned out to be Lesser Scaup, at left, and a few American coots

15-18" Male nas blue bill

13"-16" pointier bill slate-colored body

March 18 — the fog is lifting at Cooley Lake, although the distant hills are still blue and graduating to pale. I hear spring peepers and robins, cardinals proclaiming in the tops of trees, ducks that sound like distant voices distorted by static. Quail, killdeer and geese join the chorus...

Use Photos for Reference

I had my little digital camera with only minimal zoom with me so I just sketched in the landscape and a suggestion of the birds' shapes. Then I did some research at home. I added the heads of the coot and the lesser scaup and identified them with the help of my photos and those I found in books. Then I added notes about the birds along with a description of the foggy morning.

Find an Expert

My good friend and veterinarian Pete Rucker, a licensed wildlife rehabilitator, calls me when he has something he knows I'd like to draw. I've been able to work with baby skunks, raccoons and deer, as well as a great blue heron (my favorite bird) and various raptors and songbirds. What an opportunity! You may be able to make a similar arrangement with a local nature center or wildlife sanctuary. Not only will you have a chance to draw recovering creatures, observing details you'd never get to see in the wild, but you'll also have an opportunity to learn from their rescuers.

You can also consult experts through the printed page or the Internet. They'll deepen your journaling experience by helping you identify and understand what you've seen.

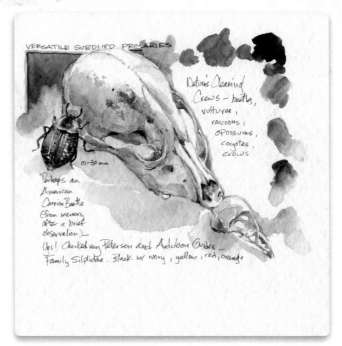

With Help From a Field Guide
I saw this beetle on my deck for only a few moments and sketched it mostly from memory. Later I was able to identify it as a carrion beetle so I added the skulls, notes and a bit about the colors used.

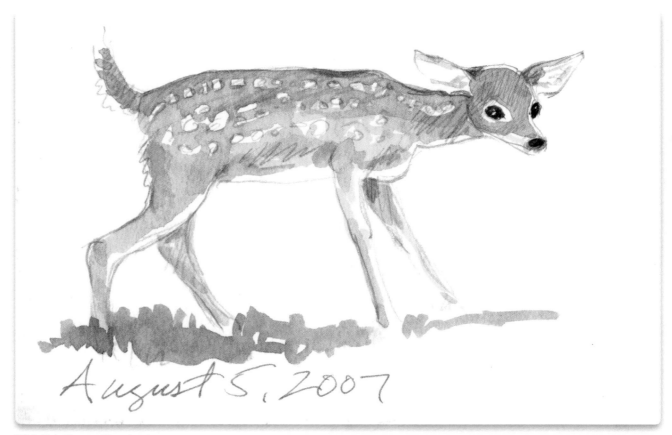

With Help From a Veterinarian
This little guy was orphaned by a car and brought to veterinarian Pete Rucker to raise. He usually has at least two fawns per summer, sometimes more—and I get the opportunity to draw them up close.

Enhance Nature With Designed Lettering

Journal pages can be made even more pleasing with calligraphy—artistic, designed or elegant handwriting. A well-designed header with well-placed and beautifully lettered notes add not only basic information but also graphic impact. Your lettering can provide balance and harmony through both placement and color.

Think of illuminated manuscripts with their images from nature, their rich color, their bold headers. We take part in a long line of artists by illuminating our own journals—as the title of Hannah Hinchman's first book puts it, we are taking *A Life in Hand, Creating the Illuminated Journal.*

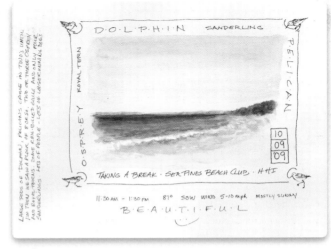

Border Treatment
There's an astounding amount of information in this tiny sketch from Pam Johnson Brickell. The little habitat sketch captures the locale. Using ink, she added the tiny wading birds and copious notes—some artistically arranged as a border.

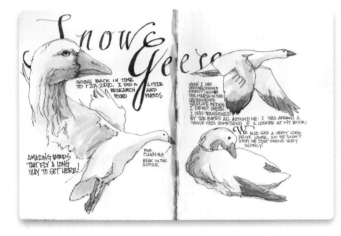

Artistic Head
Let your text and headlines complement your images, especially if you enjoy calligraphy. Gay Kraeger's done a beautiful job suggesting the shadows and reflected color on these snow geese. She then finished this appealing page with a header and text.

Calligraphic Touches
Design a beautiful and informative page, as naturalist Pam Johnson Brickell does here. This reminds me of an illuminated manuscript or an old botanical print.

TRY THIS

You can find something to learn or appreciate about nature wherever you are, and everything is worthy of inclusion in your journal. I habitually have my morning coffee on the back deck, weather permitting. One lovely day I happened to look up and notice the sun shining through the sprouts in our rain gutter. These "hanging gardens of Babylon" were too pretty not to capture.

Keep your eye open for an unexpected bit of nature— and sketch it.

1 Funny what catches your eye. This is a photo of the view that started a morning sketching session.

2 I started with a pencil drawing of the gutter and a varied watercolor wash to suggest the tiny tree sprouts.

3 The reflected color in the shadows of the new white downspout was a challenge. I saw soft spring greens, lavenders and pinks in the blue shadows, so I pushed those colors a bit.

4 I began adding the dark roof, the shadows between the plants and small, sharp details in the downspout.

5 I worked with a selection of water brushes in various sizes; one of the largest ones has a nice point and holds enough water and pigment to do the dark areas and the lettering.

6 There were tree seeds everywhere in addition to those that had sprouted in our gutters, so of course I decided to add them to the page. Before writing what they were on the page, I consulted a field guide from my collection to verify my identification.

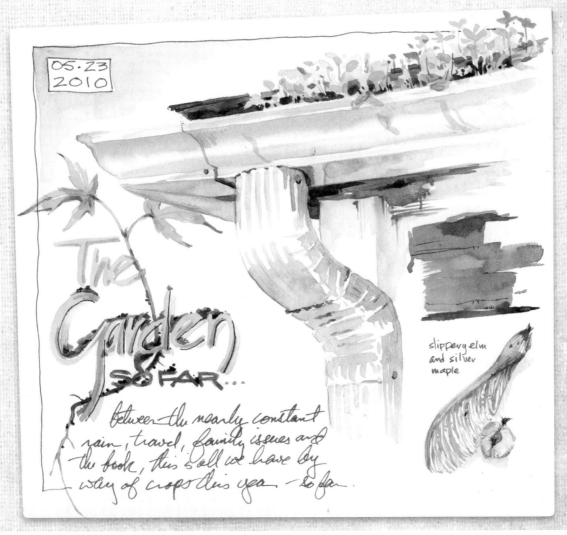

7 And here's the completed page, with seeds, captions and notes. I couldn't resist sprouting the letters themselves and adding the baby silver maple my husband evicted from the gutter.

DREAMS AND IMAGINATION JOURNALS

Use your journal to cut loose your imagination; pay attention to the images in your dreams; make personally meaningful connections; use symbols that speak to you; think about what your habitual doodles may say to or about you. You may discover what you really think or feel about something. As my friend Hannah Hinchman wrote in one of her journals, "How do I know what I feel until I see what I've written?"

Years ago I took a workshop on journaling and creativity sponsored by the Friends of Jung. It opened my eyes and helped me start seriously journaling—not just doodling or sketching. I think it changed my life.

TRY THESE

EXPLORE YOUR IMAGINATIVE POWERS

- Write down your dreams and sketch the images that come to you there. Sometimes looking at dreams with your waking mind helps you understand what was going on in your subconscious. This exercise may even lead you in a direction you need to take.
- Illustrate a story in your mind, then on your paper.
- Design a new quilt, garden, cabin or garment you'd like to make.
- Chart your golf swing—or a bird's flight.
- Plan a painting of a place from another dimension.
- Draw a friend or family member as an elf or animal.

Mystique
Ellen Burkett created a moody, mysterious effect with colored pencils on black paper. The image is straight from her imagination.

Let images flow onto your paper. Express your emotions, either with recognizable images or with lines or colors or textures. Some people make what they call Zentangles (an artform based on repetitive patterns—look it up online). Others design their own mandalas that help them get in touch with their creativity. Use whatever works for you, but do it right in your journal.

Think of an emotion or mood and then try to envision the perfect image to capture it. Don't go for the first image that you think of, necessarily, but let yourself consider for a while. Mull an idea over. Sleep on it. Then sketch it in your journal and let yourself fully experience it. Sometimes these images will surprise you with their power and accuracy.

I was once going through a bad period after the breakup of a relationship. I could not seem to let go and get over it. Then I imagined a once-bright scarf tied to a limb like a banner, blowing in the wind at the very edge of a high cliff. It was tattered and gray with age and weather and many storms. I knew it would soon lose its hold and fly away in the wind. Drawing that image in my journal was the turning point; I began to heal.

Hopefully, you'll have happier things to depict, but never underestimate the value of your journal to help you deal with pain or challenges.

Green Man Hubby
For years I've been fascinated with the Green Man motif—a face composed of or surrounded by leaves—seen in churches, cathedrals and gardens all over Europe, America and elsewhere. So I painted my husband as a Green Man.

TRY THIS
TEN THINGS THAT MAKE YOU HAPPY

We all need a change of focus when things get hectic, depressing, harried or frightening. I learned this journal trick from a young artist friend named Mandy Jordan. She would write down ten things that made her happy—or grateful—or satisfied. I've done this over and over in my journals when I need a reminder, and I recommend the exercise wholeheartedly to you.

Try it at least once; my journaling students found it very helpful. Your list can specify ten very simple, everyday things—the smell of fresh coffee in the morning, a kitten's purr, the smell of home, a loved one's voice or the existence of chocolate. Repeat them if you want, or list new ones every day. You'll find it's hard to stop at ten.

Whether it's grandbabies, an old family recipe, your pets, time to read, sketching or simply waking up to a new day, list each of these happiness makers and do a quick sketch of one or more of them.

DEALING-WITH-CHALLENGES JOURNAL

Keeping a journal can help you deal with some painful or frightening times in a manner that only an artist can. Sketching those things lets you get them outside the mind's squirrel-cage so you can gain some perspective. The images may be powerful indeed, and creating them in your journal may stir some strong emotions, but you'll be calmer and better able to deal with the matter afterward.

You may choose to track an occurrence that seems overwhelming, deal with a loss, express frustration over a lost job or calm yourself before surgery. Journaling through life's challenges has worked for me and others—and it can work for you.

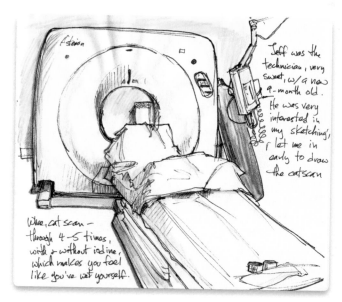

Fearful Passage
I sketched the CAT scan machine before I got to pass through the "donut hole." (Isn't *benign* a lovely word?)

SANDY WILLIAMS'S FIGHT FOR SIGHT

I bought my first journal in March 2008. On March 9th, I was partway through my second spread when the bottom fell out of my world visionwise; I was unable to finish the sketch of my brother's dog. Until November of 2009, my journal stayed on my drawing table, open to that unfinished page. (The journal still wants to open there, even though I've added many pages since.)

I've found journaling extremely helpful in dealing with my challenges. Every few months, to renew my spirit, I go back to the first page I completed when my vision started to improve. On that page I outlined some goals for my life and hopes for my future. I've also journaled about my road back to sight. I think these images and their text speak for themselves.

—Sandy Williams

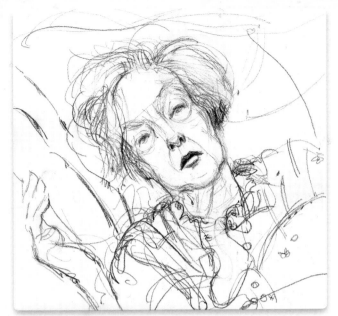

Company Through Troubled Waters
Laura Frankstone took her journal with her when she visited her mother, who had some serious health problems. The time Laura spent near her mother, drawing, talking and hearing her mother's stories, was precious to both of them. To Laura's delight, her mother loved this elegant, vulnerable sketch and wanted a copy of it. She showed it to nurses and visitors with great pride.

#3. October, 2009 until today
Right before Halloween I finally noticed a big improvement. Larger areas of my field of vision were becoming sharper and... I couldn't put my finger on it at first. Something big had happened - what was it? And then it hit me. After a year and a half Callie (and other white things) had lost her 'halo.'

That brings me to today, November 28, 2009. My vision is still very grainy, more so close up. My distance vision is clearer. When I look at Callie, my constant companion through all this, both her eyes are sparkling back at me.

Reading regular print books and the computer screen is difficult but it can be done.

The owners of this establishment are not responsible for any gloves, mittens or *socks beyond this point.

(*especially socks)

Now, I'm filled with hope that I will recover completely - but at the back of my mind there is still a germ of doubt.

#4. The Future
I Photoshopped this sign last weekend and posted an 8" x 10" copy in our back door hallway where everyone can see it as they come in. It's called "Keep Your Socks On." The only part I actually drew was the outline of Callie mouthing one of her beloved socks. Photoshop did the rest with my mother choosing the color.

This is the way you see things and I'm patiently waiting until the time I will, too. I've become very good at waiting.

I hope this summary will be of help to someone out there somewhere. And to everyone else, I hope I gave you something to chuckle about today!

The owners of this establishment are not responsible for any gloves, mittens or *socks beyond this point.

(*especially socks)

Sandy

It's hard to keep things in perspective with the state of current events in the world - the war, earthquakes, family illness. But I'm setting aside a little while today to just be happy. And today, for me, that means sitting quietly and staring at Callie's bright green bag of Purina Dog Chow. I don't say this lightly. A year ago these eyes saw this bag as being an insipid orange. I had heard, of course, of people being color blind and not being able to tell the difference between green & red. The colors seemed so different, I thought, and never really understood how that could be. Now I've been there - a world without green at all. Little by little it has been coming back to me, and today, when I passed by this bag of dog food the green glowed, not exactly the color as I remember it to be, but I'm getting close. Today I want to silently thank the package designer for Purina for choosing that color. I want to thank them for this big, goofy grin on my face.
Good job!
January 15, 2010

REPORTAGE JOURNAL

Reportage sketching is a relatively new term, but people have been doing it since artists sketched their hunting expeditions on the walls of a cave at Lascaux or documented the first battlefields, courtroom dramas and archaeological digs. Reportage makes a powerful journal entry, and once you try it, you may find yourself hooked.

You don't need to do formal reporting. Just document anything you find yourself interested in or moved by. After vandals torched an old farmhouse I'd drawn and painted many times, I sketched the embers. That helped me get the anger out of my system. Gabi Campanario, Seattle sketcher and founder of the popular blog, Urban Sketchers blog (www.urbansketchers.com), sketched a bus that slid on ice and nearly went off the road and onto the freeway. You may report on a trip to a museum or workshop or on making an eighteenth-century style garment. Document whatever you please.

Report on an Excursion
Hannah Hinchman reported in words and pictures on a day at the Teton Science School.

Report on an Event
I was concerned about a historical bridge being replaced in my town; it was very Art Deco in style and almost as old as the town itself. We were told it would be restored, but it was hard to believe as more and more parts were found to be beyond saving. I sketched it almost weekly until the project was completed (and I'm happy to report they did a very good job). All that was left at one point was the arched support; I did a speed-sketch one winter day with watercolor and a sharpened stick dipped in my wash, no preliminary pencil drawing.

Nina Johansson and her neighbors tried hard to save a bathhouse that had been a popular gathering place in Stockholm for decades. She documented the place and the process of eventual destruction; it's a sad story, but beautifully recorded.

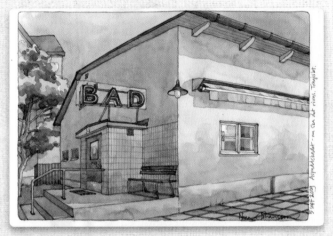

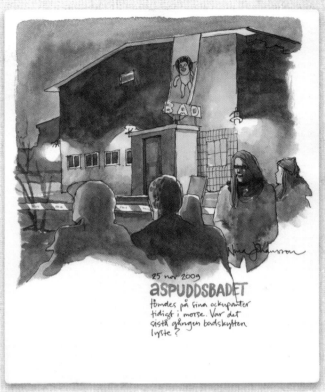

Before
Nina Johansson sketched the Aspudden Bathhouse while it still stood intact.

Protest
She captured a vigil as her neighbors protested the condemnation of the bathhouse.

Counter Measure
The bathhouse was fenced off when the protest failed.

Demolition
Here is the destruction in progress. The series is a fitting tribute to a neighborhood landmark.

SPIRITUAL JOURNEY JOURNAL

People have tracked spiritual journeys in their journals for ages. Whether you're interested in prayer, meditation, study or simply the practice of acknowledging the presence of God, your journal can help. The process of drawing often becomes a meditative act in itself.

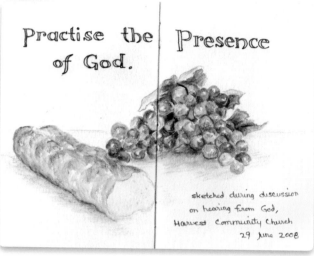

Include a Spiritual Text
Vicky Williamson often includes Bible verses or meditations in her journal.

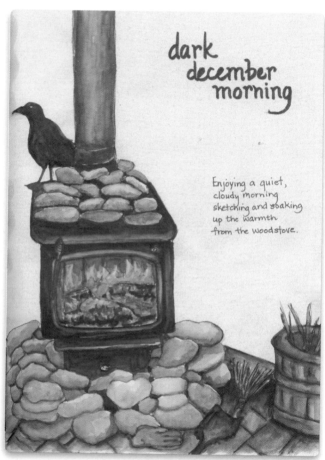

Contemplate
Maria Hodkins's journal entries often capture the spiritual. Here the sense of peace is almost palpable.

When journaling, I enter a meditative, grateful state, and feel connected to something larger than myself. ... Journaling is a sensory path to the profound, an artful spiritual pratice for my life through all its seasons.

—Maria Hodkins

Record Meditative Moments
Each morning I try to be quiet and think about my intentions for the day; it is prayer, but it's also a positive focus. Each pebble represents a day; I hold it in my hand while meditating, then move it to the pile in the handmade pottery dish. Each time I see the pebbles through the day, they remind me of my intentions.

ONLINE EXTRA

For a free downloadable PDF of my full interview with Maria Hodkins, go to http://ArtistsJournalWorkshop.ArtistsNetwork.com.

PLANNING AND PRACTICING JOURNALS

Every sketch in your journal doesn't have to be finished. I like to use my journal for testing materials and exploring. I even paste in different kinds of paper to try out so I can have them handy. You can test-drive all kinds of materials, media and ideas in your sketch journal. It's an invaluable tool.

Typical Color Test
Tests like this belong in your journal, mundane though they may be. Do be sure to write what tools or colors you're testing—those details are easy to forget.

AQUATONE

LYRA AQUACOLORS

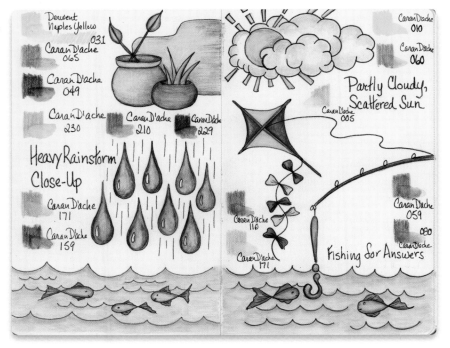

Imaginative Color Test
Jessica Wesolek likes to test her materials in fun, colorful ways. This is so much more interesting than most color charts.

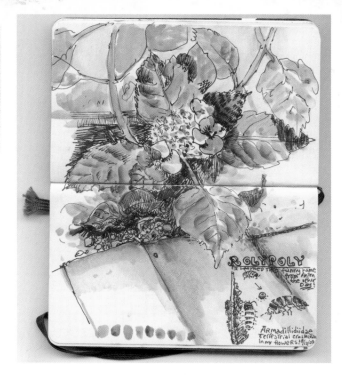

Sketch-Specific Color Test
Nina Khashchina tries out her color mixes before committing them to her sketch.

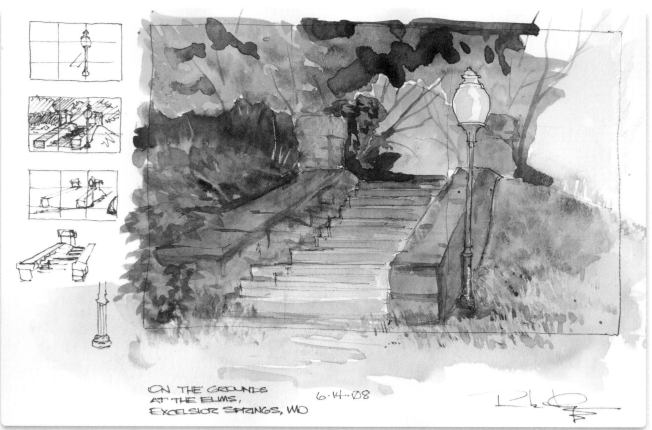

Explore Composition and Details
Watercolorist Steve Penberthy uses his sketch journal to plan future paintings, exploring format and detail as well as color. He often makes a grid to make transferring easier but doesn't worry if the finished sketch explodes exuberantly beyond the boundaries. Here he tries out his composition and sketches details on a sketch crawl to the historic Elms Hotel in Excelsior Springs, Missouri.

The sketches contain the following handwritten notes:

- Plain or fancy
- Most likely settle on the one below
- maybe window
- vent or window??
- shelves inside on this wall
- SOUTH
- WEST
- wide overhangs
- maybe, maybe 10'?
- EAST
- EAST
- storage
- wood
- shelves
- chair
- chair
- deck
- 8'
- 10'

Start Planning!
Use your journal to plan and explore ideas. Here you see my rough noodling for a garden shed/hideaway—now a reality.

TRY THIS

THROW TOGETHER A HANDMADE JOURNAL

Your journal is precious, but not too precious to use—no matter how nicely made. What's important is what you learn, what you discover, what you experience—and that you record these things so you can find them again. Every page doesn't have to be designed to within an inch of its life! Keeping a journal like that would become a chore, not a joy. I give myself permission to goof off.

So consider throwing together a handmade journal. There are many simple forms this can take. You might like my instructional CD, *Very, Very Quick & Easy Bookbinding*, which includes several different types of no-sew journals. You may find that getting away from pristine, manufactured journals is just what you need to unleash your creativity—it worked for Laure Ferlita:

I've been painting for close to twenty years, but journaling didn't come until around four years ago. I'd purchased dozens of beautiful journals through the years, each time thinking This is the one! I'm going to fill this one! However, those beautiful, pristine pages held me captive for the longest time. As a recovering perfectionist, I just knew I would mess them up! It wasn't until I made my own journals and started filling them that I moved past the paralysis of the white page.

—Laure Ferlita

INTEGRATED JOURNAL

Journaling my life as an integrated whole was an important breakthrough for me. These days I journal everything in one place and under one cover—thanks to the inspiration of Hannah Hinchman's *A Life in Hand: Creating the Illuminated Journal*. It seems so much simpler to pick up the journal du jour as I go out the door, rather than search for the nature journal (in case I might have time to stop by the sanctuary), the travel journal (if I'm headed for the airport), or a planning journal (if I want to work on a painting). My life happens sequentially, one step after another, moments tumbling over one another willy-nilly—why shouldn't my journal?

More than a diary, my journals are truly a book of days. An event like a special trip simply becomes a group of semisequential pages within that journal rather than a separate, dedicated book. If I decide to go back and add something a few pages back, I feel free to do so. I may date the new entry or I may not.

We are all many different people inside our skins. We have as many layers as an onion. We have responsibilities, jobs, families, friends, skills, needs, wishes and desires that pull us in all directions. We tend to see these things as separate and distinct—almost opposing forces. The world, work, our schools—these things seem to value compartmentalization, even while pressuring us to be multitalented.

We talk to ourselves in phrases like, "Take your pick," "Do one thing or the other," and "Focus!" telling ourselves to pay attention to one thing, one aspect of life—not realizing that the other aspects not only affect what we see or do or feel but also that they *should* do so. Life gets too compartmentalized—handwork vs. brain work, work vs. play, practicality vs. creativity.

It need not be that way—nor should it. Women, with their innate multitasking abilities, may have an easier time embracing an integrated lifestyle than men do, but in all of us, the thread of creativity flows in and out, up and down and around, weaving through all the aspects of our lives.

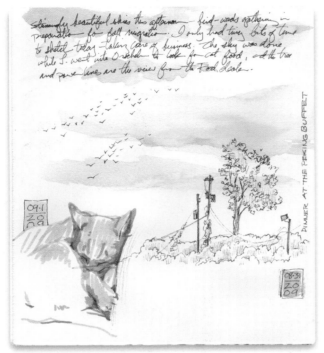

Combine Places and Days
You can combine references to a number of different places or place several day-entries on a single page.

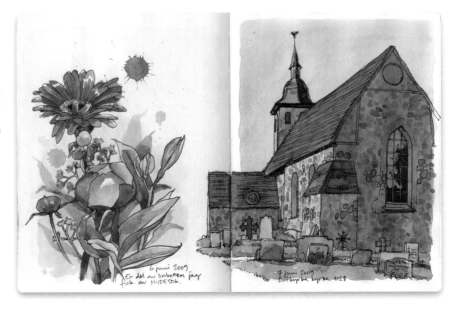

Go With the Flow
Nina Johansson lets her days flow throughout her journals. Sometimes for unity she lets an image overlap the facing page, as she did here. Sometimes each page is completely different, reflecting how changeable our lives can be from hour to hour.

All we need do is pay attention. When we do that, each part of our lives can nourish a completely different aspect, rather than diminish or fragment it.

One excellent way of accomplishing this is in the pages of your personal journal. Integrating your life, art, writing and even the mundane details of grocery lists and minutes of meetings helps pull everything in your life together rather than isolate one part from another. Paying attention to all aspects of our lives makes us whole. In our journal, words enhance and explain and expound on sketches; sketches illustrate, illuminate and elevate words. Using your sketchbook to record the mundane as well as the sublime pays the respect due to all parts of your life—and insures you'll carry your journal with you so you don't miss the sublime.

The various aspects of my life flow into each other, each enhancing the other, making my life richer and deeper than it ever was before. Nothing is so mundane it must be excised from my journal. This is my life, varied, complex and beautiful—reflected within the covers of a single book. And when I look back at those pages, life feels much less fragmented than it used to.

All in all, that's one of the goals of journal keeping, isn't it?

Make Connections
Make connections with your art as Hannah Hinchman did when she paid attention to small things that droop. Once we notice these relationships between images or ideas, life becomes so much more interesting.

Let Come What May
Whatever catches my eye goes into my journal as I see it. No more searching for "the nature journal" or "the planning sketchbook." An urban scene followed by a nature observation is fine. Next might be an entry about my cats.

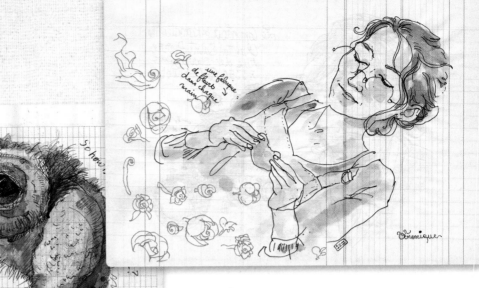

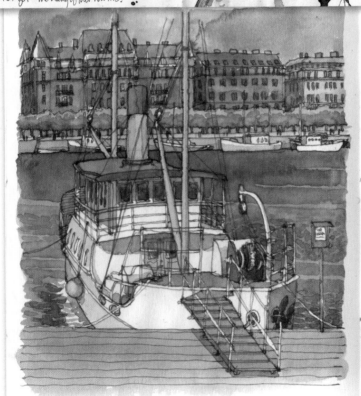

Today another day of orientation explanation of tasks. Since there are no new people on the base — everyone has been in the field at another location, it was a straightforward and rather boring day. Roger suggested that we all stay close to the compound today so I spent more time with the turkeys, watching them traverse the chain link fence, which presably maintaining what I believe he believes is a discreet distance — or useful vantage point?

09.04.10
4:30 p.m. Another brilliantly sunny spring day. 50°F Flowing and not flowing I still have not got the hang of this new nib.

Journal Artists
Top: Lapin
Middle: Roz Stendahl
Bottom: Nina Johansson

27 juni 2009
Strandvägen från Skeppsholmen

JOURNALING LIFESTYLE

This will be a shorter chapter with more internal work for you. You'll learn how to make journal keeping a habit, how to find and make time for journaling, and where to find the tools and inspiration to celebrate (or survive) the times of your life.

We're all different and we have different needs. Being honest with yourself about your goals, wishes and personality helps to keep this journaling business a satisfying habit that will see you through a lifetime. Whether you choose to journal every day or when the mood strikes, you'll find the time to do it because it's important to you.

You tried a lot of different media, approaches, techniques and journal types in chapters two and three. By now, you have a good idea of what feels most comfortable—or even essential—to you. You know how you can best express what you want to express. Media and techniques can vary, depending on your subject or the amount of time you have at your disposal, of course. Don't worry about continuity of subject, style or medium. This is your journal; feel free to go where the mood leads you.

Don't worry about perfection, or making a finished piece of art, either. It's the process, the doing of it, that's important. Remember, there's no right or wrong—not in what kind of journal you like, what you decide to journal about, how you integrate or segregate subject matter, when you like to work, how much time you spend, how you design your pages or what medium you use on any given day. There's no perfect paper or "right" brand of watercolor. Too many rules or restrictions can make you lose interest or feel obligated—even trapped. That's completely contrary to what journal keeping should be. Don't wait to find that magic brush or color, either. It doesn't exist. What exists is the relationship between brush, paper, mind and hand.

GIVE YOURSELF PERMISSION

All too often family members and friends question why we're taking time for drawing and journaling. They wonder why we're "doodling" when there's so much to be done. Maybe you even ask yourself that question. You may think that your sketchbook journaling is frivolous or selfish, but I assure you it's not. The world needs more observant, self-motivated, thoughtful, responsive, creative and happy people—not fewer.

Your journal can be a mini art retreat, a mental health day or a complement to your meditation time. You can document events around you, both personal and public. You may choose to share this creative time with friends or your children. (Many kids love keeping a small journal all their own when they see that it's important to someone they love.) When we allow ourselves time to keep our journals, noticing and celebrating the world around us and expressing our innate creativity, we become better spouses, parents and friends—better people.

VALUE OF JOURNALING

When I journal I feel alive, changing and noticing beauty everywhere. Drawing things helps me understand, slow down so I can see what's important to me and make choices.

—Nina Khashchina

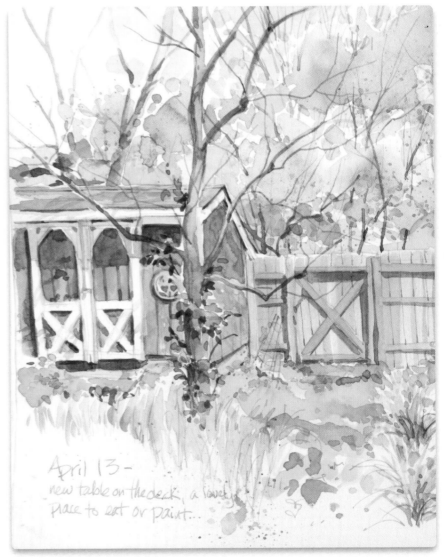

Capture the Moment
Sometimes the light is so lovely, I have to grab my watercolors and sit on the back deck to paint.

DEVELOP A HABIT

In order to form the journaling habit, you need to find the experience satisfying on a number of levels. That's why you should choose a medium (or media) you enjoy for the majority of your work. Deciding on media is small potatoes, though, because in the end, whether you choose watercolor or colored pencils or something else really doesn't matter.

People say that it takes at least twenty-one days to create a habit. If you've taken time to complete each of the exercises in the previous chapters, you may have been journaling for twenty-one days already. But developing the journaling habit really only works if you've found a way to satisfy your inner need. You chose to read this book for a reason. Maybe this is just one of many books on journaling you've chosen. Review those books to see where you are in regard to your intentions when you made those choices. Write your thoughts in your journal. Writing out your intentions or hopes can help you see them to completion.

Get in the habit of carrying your journal everywhere or make sure you always have something to sketch on, even if it's just the back of a deposit slip or a paper napkin. I've drawn on the backs of mail, canceled checks, paint chip samples and even on a bit of birch bark. You can always paste these pieces into your journal later.

KEEP YOUR JOURNAL HANDY

Always having my journal around helps. I have no excuse not to sketch because my book and paints are always in my purse. Of course, the purse has gotten larger. And heavier.

—Gay Kraeger

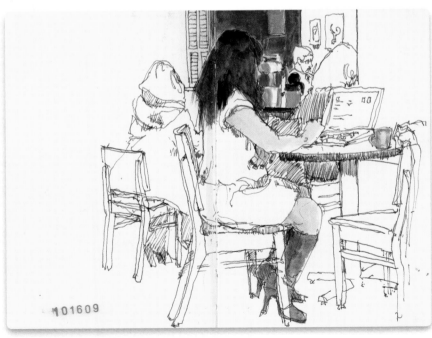

I find drawing comforting. I like to push myself to see if I can get something down quickly. If I can't get it, I use my memory and knowledge to finish the drawing. I also believe in solid composition to create my images. Very seldom are the groups that I draw really groups. I put people and animals together on the page to make a somewhat cohesive image.

—Fred Crowley

Carry a Pocket Journal
Like Fred Crowley, you can develop the habit of carrying a very small sketch journal. The diminutive size will allow you to tuck it in a pocket and work in public unobtrusively.

DISCOVER WHAT'S IMPORTANT TO YOU

What is it about journaling that's important to you? Knowing the answer to that question will help quiet the inner critic that says you're not good enough or you don't have enough time. It will inspire you instead to follow that inner urge to pull out your journal and sketch!

For me, journaling encourages celebration of the moments of my life—delight in the way light strikes a tree deep in the forest or the soft fur of my kittens or the stained-glass glow of sunlight through the geraniums on my front porch. It reminds me to stop and pay attention to nature, the passing moments and creation—and to be grateful for the beauty all around me. Life becomes richer and deeper, all for the cost of a few moments' attention and response.

My journal helps fix images and events in my mind—things like a special place while traveling, a kitten's pose, or a bit of nature, common or rare, in my own backyard. One year my husband and I enjoyed watching an albino chickadee near our house. I'd have forgotten about it if I hadn't made a quick annotated sketch.

Journaling helps calm me when I'm nervous or frightened. When tornado sirens sound, I sit on the basement steps and sketch. It soothes me when I'm stressed. It helps me chill out when I'm ticked, whether I sketch what I'm actually upset about or just let color or bold lines express my emotions. Sometimes I simply allow nature to soothe me as I pay attention to my drawing.

I'm not sure I truly see something unless I've drawn it, be it a complex machine, a flower, a tree or a well-loved face.

So again I ask, what is it about journaling that's important to you?

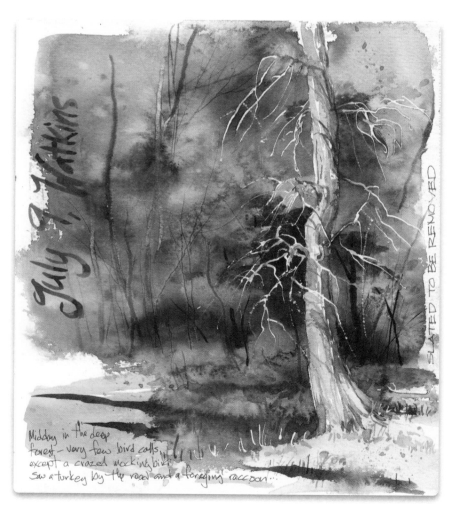

July 9, Watkins

SLATED TO BE REMOVED

Midday in the deep forest—very few bird calls except a crazed mockingbird. Saw a turkey by the road and a foraging raccoon...

Don't Let It Get Away!
Sketching allows me to hold on to the moments. I used a bit of liquid mask applied with a sharp stick to let the light-struck calligraphic limbs stand out against the dark forest.

GET IN THE ZONE

What I like best about journaling is getting in "the zone" while drawing—you know, like when you concentrate so much on what you do, that you lose track of time. It's just you, the pen and that subject you're trying to capture. It's very soothing, and afterwards I always feel as if I'm waking up or coming back to the world. That must be what meditation is for some people.

—Nina Johansson

FIND TIME

So how do we find time for this endeavor? No one is so busy they don't have a moment here and there through the day. Turn off the TV and the cell phone, get away from Facebook, skip that shopping excursion. You'll be surprised at how much time you can find to use as you wish.

Notice when you feel the most awake, responsive or creative, and schedule as much time as you can for your journaling then, even if it's only for a few precious moments.

Get as much done as you can in the time you have—even if it's only seconds. You'll find you usually can get enough information down so you can finish the sketch later, if you wish. Sometimes quick splashy washes give form to simple linear sketches and bring them to life.

Celebrate something simple—an apple, an egg, a shoe—something you can sketch quickly. You'll find paying attention to it allows you to see it almost as if for the first time.

Nothing Is Too Simple
This is the corner of a service station out on the highway. I liked the way the light played over the varied curves and angles, so I quickly sketched them in ink. Later I added a bright touch of color.

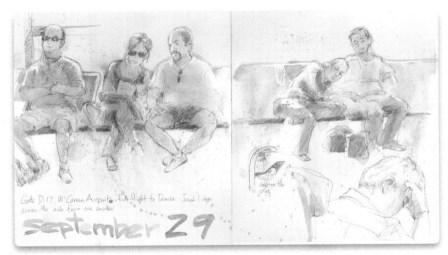

Start Now, Finish Later
I had only a ballpoint to sketch these fellow passengers waiting at the airport, but I remembered how the desert light poured in the window behind them, throwing them into soft shadow. I added the color later, when I got home.

OPPORTUNE TIMES

I draw in the park while my son unwinds after a day in preschool, while taking a breather when hiking, when chewing my lunch, while cooling down after a jog, in the doctor's office, while waiting in a long line, after waking up before everyone else does. The perfect time is right now!

—Nina Khashchina

WORK ANYWHERE

Some people are nervous about sketching in public, but usually no one pays any attention, particularly if you work in a peripheral location—a booth, a bench under a tree, off to one side or against a wall. Don't stare rudely, but sneak quick peeks and then draw a bit. If you're caught looking, simply smile. Some sketchers like to wear dark glasses or a broad-brimmed hat to offer a bit of privacy, but generally speaking, people are usually too preoccupied with their own affairs to notice what others are doing.

Working small is less intrusive, of course, if that's important to you. But you'll find that the more you sketch in public places, the more used to it you become—and certainly you'll enjoy the additional sketching time.

Working small does have other advantages, though. If your journal is tiny, it takes less time to fill a page. I keep a couple of small homemade accordion-fold books in my vehicles. Then if I have a few moments to wait while my husband gets gas or runs into the hardware store, I have something to sketch on, even if I've left my regular journal at home.

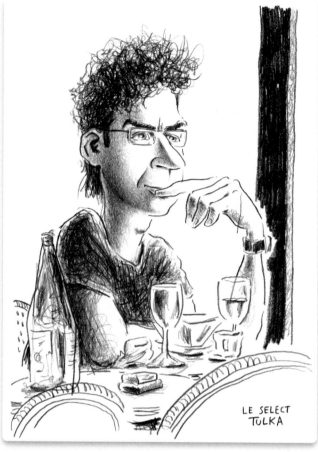

Work in Public
Rick Tulka works in public every day. I suspect he's become a fixture at the Café Le Select in Paris. His collection of interesting faces is a delight.

Capture the Essense
In this small pencil sketch, Catriona Andrews went for the values for a powerful, moody sketch of a backlit fiddler in action. The strong diagonal strokes underscore the sense of movement.

> ### ENJOY PUBLIC ENCOUNTERS
>
> *When I work in public, I find that most onlookers are intrigued with the process of journaling, and it often creates an entry into a conversation or a friendly encounter.*
>
> —Maria Hodkins

WORK FAST

Cultivate fast sketching techniques, such as those described on the next few pages.

Gesture Sketch

Gesture sketches—quick drawings intended to capture the action, movement or essense of your subject—can be done in as little as three to thirty seconds. No need to produce a masterpiece every time—or *ever*!

For sessions that are a bit longer, you can set an alarm clock. Allow yourself ten minutes, twenty, thirty, an hour—whatever you think you can spare for your journal time. When the alarm goes off, stop—or treat it as your creative snooze alarm and finish as quickly as you can. You can always set the timer again.

By the way, it's OK to let the answering machine or service pick up the phone. Telephones or cell phones are a convenience, not your master. It isn't rude or selfish not to answer instantly. There are few matters that won't wait until you've had a bit of time for yourself.

Of course, sometimes you'll have time to kill, like when you're waiting for a plane, a friend, the doctor or lunch. Rather than picking up a magazine or getting twitchy, try sketching in your journal. That makes the time pass quickly. Make notes about what you see or hear (other conversations? thunder? birdsong?) or how you feel. Is waiting making you tense? Are you frustrated? It's OK to write that, too, but in all likelihood, finding something to sketch will engage your attention and create a calming effect, much as meditation does.

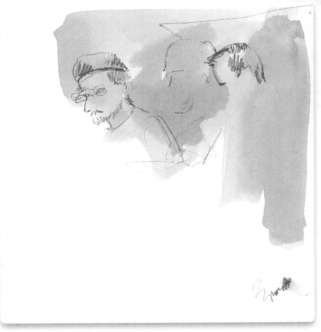

Gesture Sketch
I did these *very* quick gesture sketches as I listened to musicians at the Jazz & Wine Fest in my town. To tie the images together and give a sense of the very hot day, I added a splash of vivid color later. The overall effect reminds me of how fast these guys were playing, despite the weather.

Work Speedier Than a Kitten
Ellis is still just a kitten, and he moves *fast*. I did quick gesture sketches with a brush and ink and added color later.

Grids

You may enjoy gridding a journal page, especially when you know you won't have a lot of time to spend. Divide a page into days of the week or just a pleasing number of segments, such as four, six or nine. You can graph as much as a whole month with tiny, quick overviews.

Try marking the passing of time with sequential studies on a single page. (You can also do this over several pages.) You may want to return to a page seasonally, marking seed, sprout, flower and fruit. Consider revisiting a single locale in spring, summer, fall and winter. Or you could compress the hours of a day onto a single page.

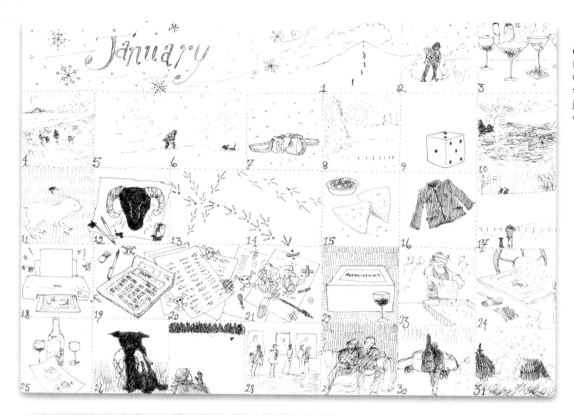

Grid an Entire Month
It's fun to look at Catriona Andrews's tiny images and see just how busy a month can be!

> ## ONLINE EXTRA!
>
> For a free downloadable PDF of an interview with Catriona Andrews, go to http://ArtistsJournalWorkshop.ArtistsNetwork.com.

Sequential Study
Looking out her window, Catriona Andrews did quick sketches of a single snowy day.

TRY THIS

NINE-SQUARE GRID

If you're new to grids, the nine-square variety is good for testing the waters. I decided to do one of these grids during a period when I was particularly busy. I made a grid for as many days as the page would hold—nine in this case. In the past, I've done grids like this all in ink, but I was in the mood for color during the gray days of winter.

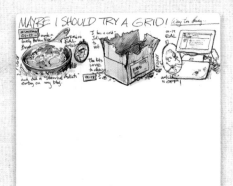

1 I marked off nine roughly equal squares on a page and then began adding one image each day in ink, adding color as I had time.

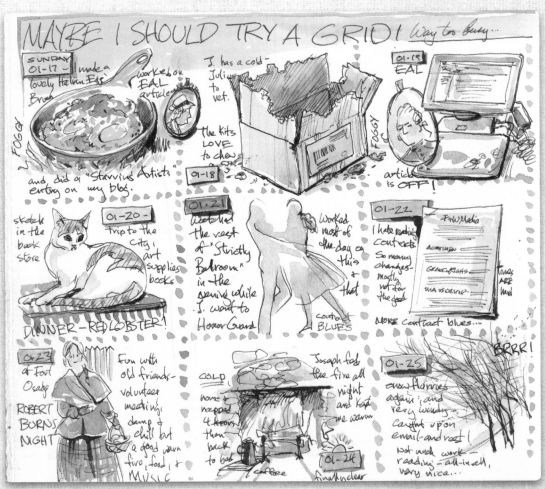

2 Here's the grid filled in. The dancers really got the speedy treatment! After I filled all the squares, I added simple washes, a graphic section divider and a bright header.

Composite

On composite pages you just keep adding images, related or not. No rule says each sketch must follow the one before. If there's a page that looks unfinished or is obviously meant to be a composite, feel free to add words or an image as you please. Take comfort in knowing that any one quick sketch doesn't have to fill the page; you can add more sketches later.

Look for ways to tie disparate images together—borders, background color or texture, lines or whatever.

I think it's better to draw very little almost every day than to draw nothing for many days.

—Nina Johansson

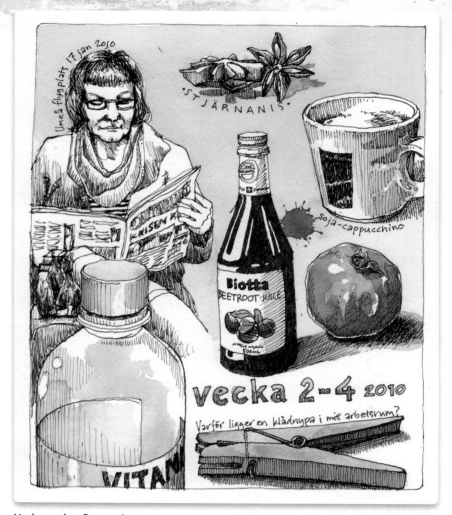

Hodgepodge Composite
Nina Johansson covered a week by sketching a variety of things that caught her eye. Then she brought the sketches together with color and a graded background wash.

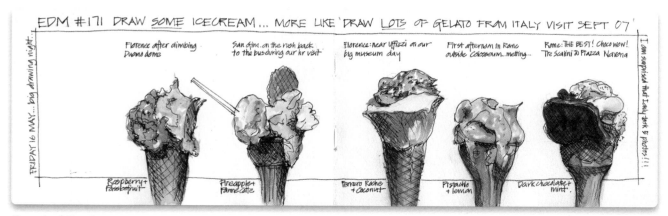

Organized Conglomerate
While touring Italy, Liz Steel marked the passing locales with gelato rendered in quick ink and watercolor sketches.

Capture the Time of Day

For an interesting challenge in working fast with fascinating results, sketch at dawn, dusk or night. You'll be forced to work quickly, simplifying not only values but shapes.

Consider the three ways that Nina Khashchina simplified the fleeting moments of dawn.

6:20 A.M., November
Nina Khashchina chose ink and a gray wash to capture the flattened values of those moments before full day in autumn.

6:20 A.M., March
A quick sketch in purple ballpoint pen works well to capture late winter dawn.

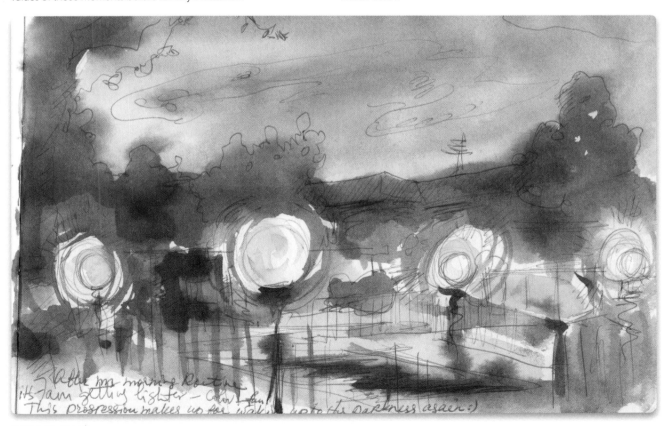

7:00 A.M., March
Nina went for a bit of color on this morning, as the flatness of the values lifted.

Here you see are more quick renderings of that elusive light seen at sunrise and sunset.

6:05 P.M., January
Sandy Williams explained her effort to capture the glorious winter light right in her notes on the journal spread. Watercolor pencils work beautifully for her.

March Morning Fog
Fog lifts quickly; details come into view and the light changes. Early one foggy morning, I worked wet-into-wet at top speed on an observation tower, adding details after the initial wash began to dry.

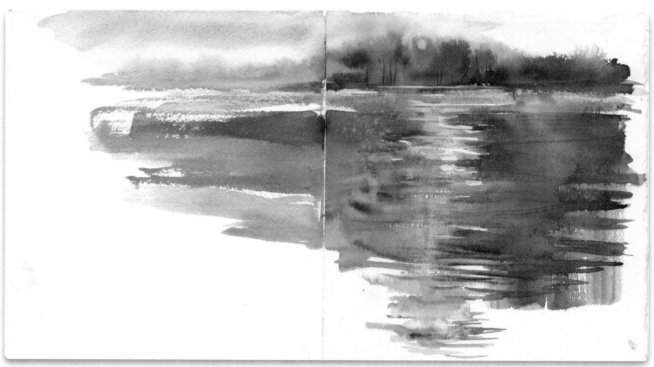

Fast Work at Sunset
I arrived at the lake just before sunset and worked very quickly, wet-into-wet, to capture the liquid light. When working on something like this, it's best to use the largest brushes you can in order to cover the most ground at speed. (The two pages aren't quite the same paper texture, but I don't mind the effect in my journal.) Check out my You Tube demo of the techniques I used for this sketch (www.youtube .com/watch?v=rVTZ6S0wg-4).

Add More Later

Remember when you're forced to work fast that you can always add more to a page later.

Save space

Lack of time isn't always the issue. You may not want to dedicate more than a single page to one theme or experience, even though you have plenty of time. Usually when I travel by air, only one page or a single spread is set aside for getting there (and and maybe getting back, too). I just keep adding images until the page feels full or I reach a pleasing composition.

A Little Now, A Little Later
Left: Night was rapidly falling, so I did a quick vignette of the forest's edge, using drybrush, wet-into-wet, and some spattering to suggest leaves and redbud flowers. I drew twiggy details into the almost-dry washes, using watercolor applied with a sharpened stick.

Right: Later I felt my sketch needed more punch, so I added the darks and lights of the tree trunks when there was more light. Opaque white made the sycamore trunks stand out, and a bit more hot pink spatter gave the feeling of the redbud blossoms in the foreground.

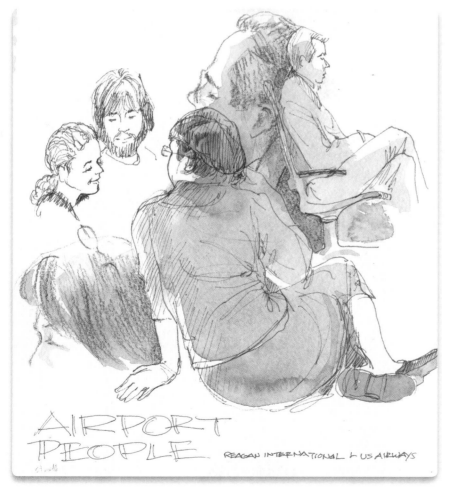

Passing Time in a Small (Journal) Space
Ink, colored pencil and watercolor washes helped pass the time while I waited for my flight.

MAKE TIME

Set aside some "me" time for journaling, whether early in the morning, after everyone's in bed, on your lunch break or whenever. Let's explore a few ways to make "me" time happen.

Make an Appointment

Make a date with yourself—and *keep it*. If you have to break your "appointment," don't stress and, above all, don't give up. Just reschedule as you would anything else. Your "me" time is as important as any other appointment. These tips can help you keep and make the most of your journaling appointments:

- Set an alarm to remind you of your "me" time—perhaps a nice musical reminder or a chime on your computer. Of course, if you need to be reminded to *stop now*, maybe a loud, insistent sound would be better.

- Set a timer when you know you have a limited amount of time to work. The urge to keep checking the clock doesn't do much for the quality of your journaling time, and a timer sets you free from stressing about losing track of time. (Keep in mind that you can reset the timer if you need more minutes.)

- Enlist your family's help. If they know how important journaling is to you, they may be supportive and help you make time.

Take a Class

There's a world of support out there for your endeavor—you may find a class at a local community center, college, nature center or scrapbooking store. Having others around you working at the same thing at a set time will help you set aside time to form a habit.

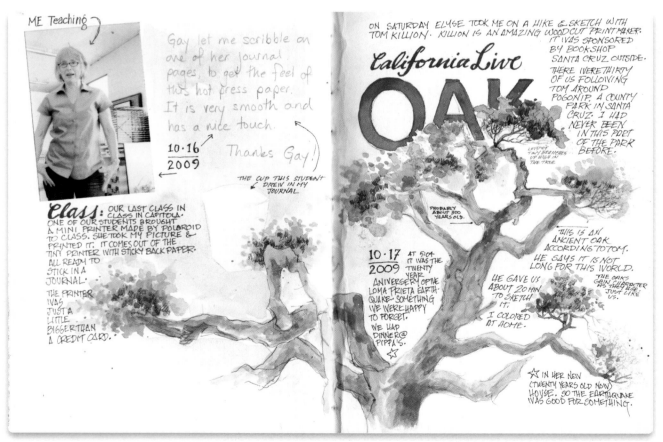

Workshop Fringe Benefits

Gay Kraeger let one of her workshop students write and sketch in Gay's own journal to get the feel of the paper. The student took a photo of Gay, which Gay pasted in her journal next to the student's writing. Both teacher and student came away from the workshop with a little something extra.

Join a Sketch Crawl

Another way to carve out time is to set up a sketch crawl—a time to meet with like-minded friends for the purpose of sketching in your journals. Somehow, having others involved when you set aside sketching time makes you more accountable. Perhaps the inner critic is more likely to see the importance of an appointment. Perhaps knowing you have an "accomplice" emboldens you. One of my students now has a weekly watercolor journaling date with a group of friends.

One thing you can be certain of is that meeting with other journal keepers and then sharing your sketches over a meal or a drink makes for a richly enjoyable experience. My little sketchcrawl group meets year round, outdoors and in.

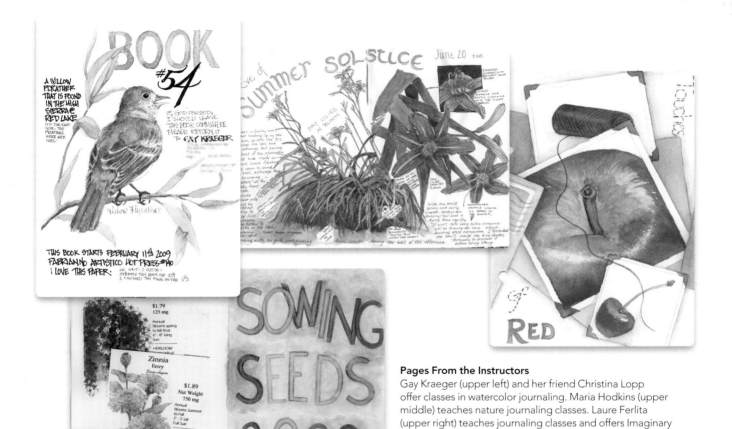

Pages From the Instructors
Gay Kraeger (upper left) and her friend Christina Lopp offer classes in watercolor journaling. Maria Hodkins (upper middle) teaches nature journaling classes. Laure Ferlita (upper right) teaches journaling classes and offers Imaginary Trips online. Jessica Wesolek (bottom) combines lettering with her classes.

TRY THIS — PULL OUT THE VIRTUAL SCISSORS

Have you found that in order to journal with any regularity, something needs to be cut out of your life—something counterproductive or crazy-making? Grab those virtual scissors and cut out that something. Or maybe you prefer to imagine tweezers or, hey, even a chainsaw! Whatever the cutting tool you imagine, sketch it. Or maybe sketch yourself jumping in a hot air balloon and floating above that time gobbler. Have fun with this exercise. You'll be amazed at the power it gives you over whatever's standing in your creative way!

HONOR THE TIMES OF YOUR LIFE

Journals are wonderful for celebrating milestones. New babies, new homes, a marriage, a dream vacation—all are grist for your journaling mill.

Journals also help us cope with those much more difficult times, giving us distance and perspective, reminding us of what we still have, distracting us from worry, calming us.

Preserve Youth
I got to spend quality summer garden time with my "fairy godchild," and, of course, I had to record it.

we drove through Hardin Norborune and Carrollton on the north side of the Missouri River, then crossed on Old 24 Hwy at Waverly—orchard country! Stopped at Shreimans for Peaches, then the winery, where we had a delightful light picnic of sharp cheddar (Missouri) and wine. Fellow revellers left us the remains of their bottle and a few crackers. Lovely!

NATURALLY, I CHOSE THE SHADY GRAPE ARBOR!

Baltimore Bend Winery, a 24 Hwy

Extend the Honeymoon
My husband and I stopped at a small winery on one of our weekend "honeymoons"— sweet memories!

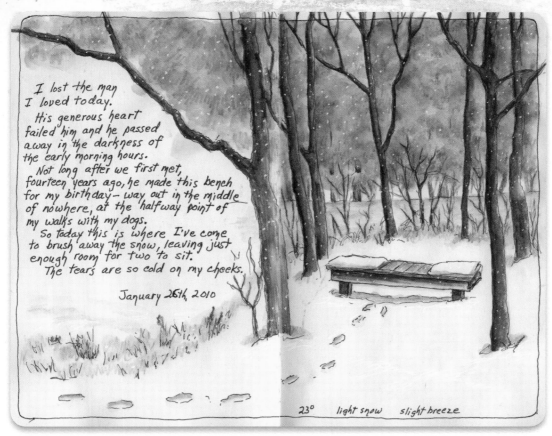

Work Though Love and Grief
Sandy Williams records the loss of her husband in a beautiful way.

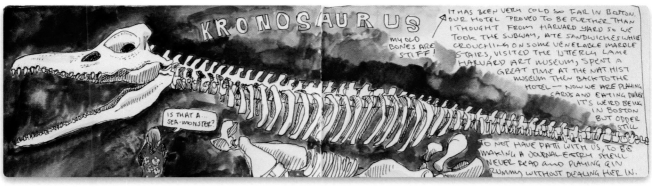

Cope as Life Goes On
With the loss of his wife, Danny Gregory turns to his journal to keep him functioning. His notes are honest and poignant.

I resumed writing and drawing in my journal less than a week after the death of my wife, Patti. The journal was the only confidante and sounding board I had, a refuge that had always given me a way to gain perspective and insight. I find that continuing to record and paint my life and its changes has been key to dealing with my grief. And it kept me in touch with Patti; I had always shared the pages of my journal with her and, somehow, continuing to fill them kept me connected.

—Danny Gregory

ONLINE EXTRA!

For a free downloadable PDF of Danny Gregory's full interview, go to http://ArtistsJournalWorkshop.ArtistsNetwork.com.

USE YOUR JOURNAL AS A LEARNING TOOL

Continuing to learn throughout our lives keeps us interested in the world around us, and your journal can definitely be a learning tool. Those sketches you make of an unfamiliar plant or flower can help you to identify it later in a field guide, online or with the help of an expert. My grandfather lived to be 97, and he never stopped learning—and, yes, he kept a journal of sorts! Life was a continual joy to him, and I think that's one attitude that keeping a journal can encourage.

Track the passage of time or zero in on a single aspect of nature with sketches. You might like watching a butterfly emerge from its chrysalis and dry its wings or a baby bird discovering the world. Some flowers open and close all in a single day—or even a morning!

Everything is worthy of our respectful attention. I got over a lifelong fear of spiders by making myself draw them in my journal, studying their shapes and colors and the variety of their webs. Amazing—no more fear, and a new appreciation for their beauty and variety.

If you're taking a class, what better place to keep your notes (and attendant doodles) than in your journal? You'll remember what you've learned much better if you've also sketched it. I'm not sure I'd recall ammonites and trilobites if I hadn't drawn them in my journal. Taking quick notes concerning things you're curious about will keep you learning all your life—and curiosity will keep you young and vital.

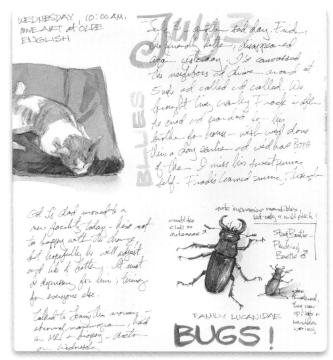

Name That Beetle!
I found my cat playing with a large beetle that had somehow gotten into the house. I sketched the beastie and took measurements before releasing him into the backyard. The next morning, I identified him in *Peterson's Field Guide to Beetles* and added the more scientific notes, like his Latin binomial, habits and gender.

THE MAKING OF A REGIONAL EXPERT

Nature has infinite secrets to reveal. I keep track of the movement and stories of the natural world on my pages, rooting my sketches and words in time and place. It's an ecological perspective that gives me insight into how the inner and outer worlds interconnect. Notes on weather, temperature, seasonal changes, when the sandhill cranes migrate, the throaty sounds of the bullfrogs in June and the turning of the aspen leaves in autumn fill my pages. I capture insects in a jar and look at them under a microscope, then paint their incredible iridescent scales or understand the engineering of the body of a grasshopper for the first time. In my journal I can be a citizen scientist, unleashing curiosity and fostering discovery. Through observation and notation I become an expert of sorts of nature's activities in my own local region. I can begin to predict the date of the first big snow or when the peaches will be ripe for picking by leafing back through my old journals. Because of the journals of Meriwether Lewis and William Clark, we gained so much knowledge of the flora and fauna of unexplored territories. Who knows what important data might one day be discovered in some ordinary artist's journal?

—Maria Hodkins

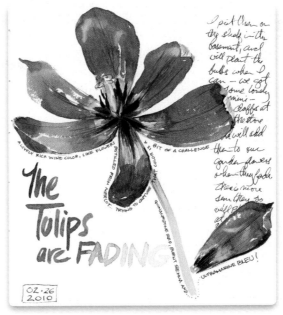

The Tolips are FADING

02·26 2010

Record the Passage
When I first picked these tulips, they were tight, graceful buds. Four or five days later they were blowsy and dropping their petals—but still beautiful.

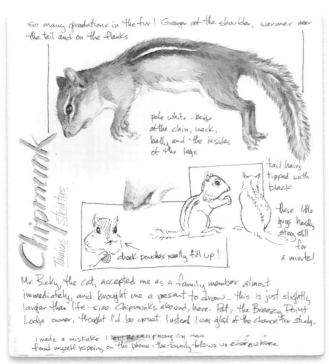

So many gradations in the fur! Grayer at the shoulder, warmer near the tail and on the flanks

pale white - beige at the chin, neck, belly and the insides of the legs

tail hairs tipped with black

these little guys hardly stay still for a minute!

cheek pouches really fill up!

Chipmunk Tamias striatus

Mr. Bicky, the cat, accepted me as a family member almost immediately, and brought me a present to draw - this is just slightly larger than life-size. Chipmunks abound here. Pat, the Breezy Point Lodge owner, thought I'd be upset. Instead I was glad of the chance for study.

I made a mistake. I left the cell phone on and found myself yapping on the phone - the family follows us everywhere

Pay Final Respects
My cat's natural instincts provided me with the opportunity to sketch this chipmunk up close and personal—albeit dead. If we can overcome a natural aversion to death, we can study nature much more closely in our journals. (Just don't touch a dead creature, especially if you don't know what killed it.)

TRY THIS
SKETCH THE "UNSKETCHABLE"

Do you have preconceived notions about what is or is not worthy to sketch? Do you feel as if you should look away from a dead squirrel, or a live snake or spider, for instance?

Try to figure out where your negative feelings to certain potential subjects for sketching come from. Did your mother tell you something was gross or disgusting? Did someone criticize you as a child for wasting time drawing something that wasn't "pretty"?

If you can remember how you acquired the negative feelings, make note of it. If not, simply sketch something you might not have considered acceptable, for whatever reason. You may enjoy an impish sense of rebellion while you're at it. Make it fun, not scary.

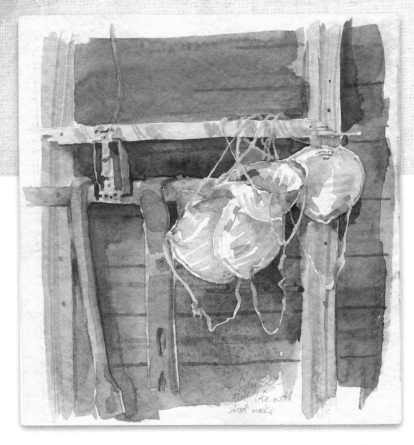

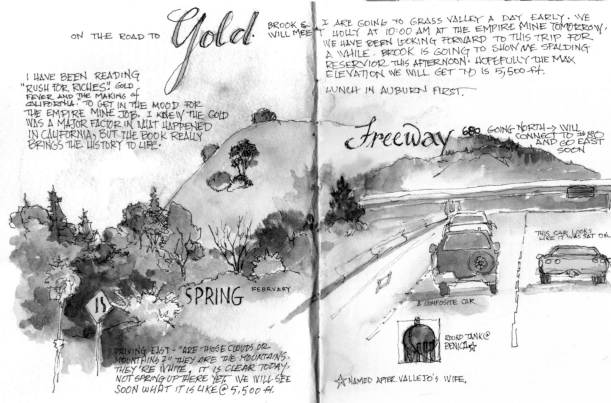

ON THE ROAD TO *Gold*. BROOK & I ARE GOING TO GRASS VALLEY A DAY EARLY. WE WILL MEET HOLLY AT 10:00 AM AT THE EMPIRE MINE TOMORROW. WE HAVE BEEN LOOKING FORWARD TO THIS TRIP FOR A WHILE. BROOK IS GOING TO SHOW ME SPALDING RESERVIOR THIS AFTERNOON. HOPEFULLY THE MAX ELEVATION WE WILL GET TO IS 5,500 ft.

LUNCH IN AUBURN FIRST.

I HAVE BEEN READING "RUSH FOR RICHES" GOLD FEVER AND THE MAKING of CALIFORNIA. TO GET IN THE MOOD FOR THE EMPIRE MINE JOB. I KNEW THE GOLD WAS A MAJOR FACTOR IN WHAT HAPPENED IN CALIFORNIA, BUT THE BOOK REALLY BRINGS THE HISTORY TO LIFE.

Freeway 680 GOING NORTH → WILL CONNECT TO #80 AND GO EAST SOON

SPRING FEBRUARY

DRIVING EAST - "ARE THOSE CLOUDS OR MOUNTAINS?" THEY ARE THE MOUNTAINS. THEY'RE WHITE. IT IS CLEAR TODAY. NOT SPRING UP THERE YET. WE WILL SEE SOON WHAT IT IS LIKE @ 5,500 ft.

THIS CAR LOOKS LIKE IT WAS SAT ON

A COMPOSITE CAR

ROUND TANK @ BENICIA ☆

☆ NAMED AFTER VALLEJO'S WIFE.

PULLING IT ALL TOGETHER

By now you probably have a pretty good idea of what feels best to you—a specific medium (or set of them), the type of journal book that suits your needs (whether commercial or hand-made), a "voice" you feel most comfortable using, a theme you want to explore further or simply the satisfaction of moving ahead with your own creative goals.

So, what *do* you like best? Have you discovered new directions or themes? Have you tried a new medium that's become a must-have? Now is the time to take some compass readings to see where you've been, where you are and, most important, where you want to go.

Journal Artists
Top left: Cathy Johnson
Top right: Nina Khashchina
Bottom: Gay Kraeger

FAVORITES

If I could, I'd devote these next few pages to *your* favorite journaling techniques, practices and subjects—but that would require a different book for each reader. Hopefully, looking at my and other journalers' favorites will get you thinking about what you like best—and why.

Favorite Media

My personal media standbys are wax-based color pencil with wash, ink with wash, and ink with a bit of color (or colored ink). They're immediate yet colorful.

Colored Pencil and Wash
This quick colored pencil sketch came to life with loose, wet-into-wet washes. The lines provide a framework that allows a free application of color.

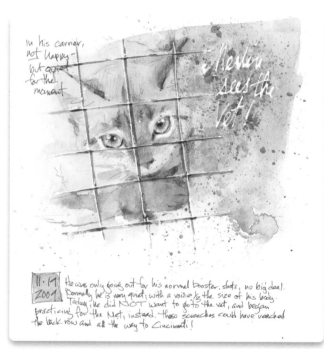

Colored Pencil and Masked Wash
I did little more than sketch my cat's beautiful blue eyes, the shape of his head and a quick impression of the metal-grid door of his carrying cage. Later I used liquid mask on the grid and the lettering, and splashed in color, wet-into-wet. This is one of my favorite pages.

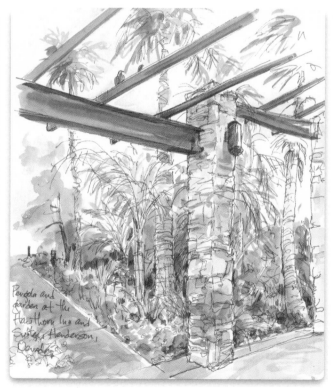

Ink and Wash
Here ink provides the framework for loose washes. As long as the ink is waterproof and has had time to dry, you can lay washes right on top without lifting or smearing.

Favorite Style

Everybody has style! Some go for simplicity, others like more detail. You may tend to carefully design your pages or you may take a more haphazard approach.

Perhaps you have a favorite design element or two. Fred Crowley and Liz Steel both use patches—but for different reasons.

Also consider your writing style. Do you prefer a fun or a serious approach? Are you a just-the-facts type or do you use your journal to meditate, dream or explore your imaginative limit? Do you use lots of words, few words or no words?

TRY THIS

TEN JOURNALING FAVORITES

Remember the "Ten Things" list of what you're grateful for in chapter three? How about doing a new list (illustrated or not) of ten things that you especially enjoy when journaling. Is ten too many or too daunting? Then see if you can distill the list into three to five things. Or do a number of these lists on a single page. Use a different pen; write in a different direction—enjoy the process while you think about what you like about journaling and what it does for you.

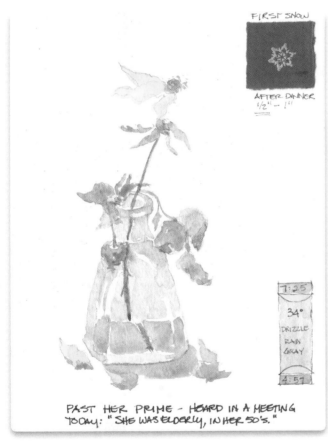

Visual Wordplay
Jeanette Sclar obviously has fun with her journals—and life!

Journaling is a very new activity for me. I was always intimidated with the possibility of doing a "bad" page and being stuck with it in a book, so I did all my work on loose sheets, which makes it very hard to find things when I want to. Then I learned that you can paste over a bad sheet—and I've never looked back.

—Jeanette Sclar

Sample Lists
I journaled these lists on paper meant for pastels; I like the subtlety on this rather serene page.

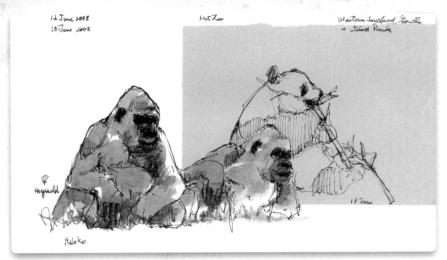

Patch as Design Element

Fred Crowley uses patches when he's not pleased with something—but he uses them creatively! Notice here that the patch is cut to fit around the gorillas and sets the panda apart with color, line work and background. You'd never suspect it wasn't part of the original design concept.

Patch as Decorative Element

Liz Steel uses patches for decorative impact, and does it ever work for her! The hot pink patterned paper sets off the rest of her composition, making a strong graphic statement.

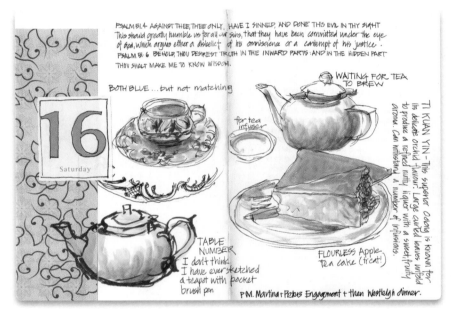

Sketch What You Love

Liz Steel's journal reveals interests in tea, tearooms, travel and buildings. That last item isn't surprising because Liz is an architect. This spread tells about Liz's meeting for tea in Scotland with fellow sketcher Wil Freeborn.

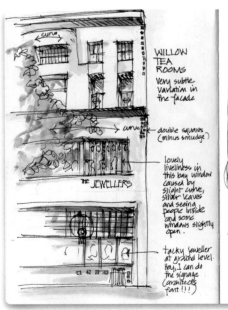

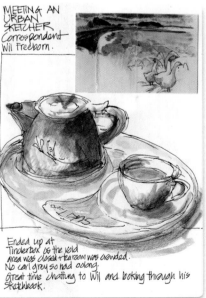

Favorite Subjects

Subject matter often says a lot about what a journaler loves. Many of the sketches in this book are from my travels—that's one of my favorite uses of my journal. It lets me take the time to experience my subject much more fully when I'm home. Even years later, I find I remember the moment clearly. Sounds, scents, the people I was with—all the circumstances come clearly back to me.

Travel and tearooms obviously mean a lot to Liz Steel. Danny Gregory loves dogs, and it shows.

Once in a while, enthusiasm for a subject becomes infectious, inspiring other journalers to try their hand at it. Usually, though, a favorite subject remains more personal.

India Ink, Watercolor and a Favorite Subject
Danny Gregory confesses that although he's fairly committed to dip pens and India ink, he's recently become devoted to Dr. Ph. Martin's liquid watercolors. The combination certainly works on this composite dog page.

WHY I LOVE TO SKETCH DOGS

Dogs have always been important to me. When I was a child, I fantasized about being a vet. I've always owned dogs and have drawn them since I was able to hold a crayon.

Dogs make great models. They'll hold still for ages, have great personalities, don't mind posing nude and work for snacks. They allow me to draw bones, muscles and fur, and they come in so many shapes, colors and sizes.

Oh, and my initials are D. O. G.

—Danny Gregory

Doggy Humor
Danny Gregory's quirky sense of humor often surfaces on his journal pages. Dogs provide the perfect expressions.

Model Bear

Liz Steel's funny little bear travels all over the world with her. Not only does she sketch and photograph him on the spot, but other art journalers also get in on the act. I've seen at least six other artists' renditions of him (including my own) from all over the world.

ONLINE EXTRA!

To see sketches by several different artists of Liz Steel's bear, go to http://ArtistsJournalWorkshop.ArtistsNetwork.com.

Family Favorites

My two favorite subjects are my husband, Joseph, and my cats—often together. Here, Joseph and our huge cat Merlin grab a quick nap. (This page doesn't need any text; the image says it all.)

Family Fun

Of course you can also cut loose and have fun! Joseph made a face, and I caught it on my journal page.

THINGS THAT DON'T WORK

We all have our favorites when it comes to journaling. You may have discovered how well ink and watercolor work in combination, or you may love the apparent dimensionality of toned paper or delight in the rich, textural complexity of collage. You may love pages full of quick sketches or prefer a single crisp image. The immediacy and challenge of sketching on the spot may be your cup of tea, or you may prefer a quiet, meditative approach before starting your day. You may love working at speed or opt for taking it slowly. Journaling may be a communal affair for you, or it may be intensely private.

You probably also have a pretty good idea by now of what doesn't work for you—or what doesn't bring you as much pleasure. Try to keep those things to a minimum so that journaling doesn't become a chore. Sometimes things that don't work under one set of circumstances work just fine under another.

TRY THIS

LIST WHAT DOES OR DOESN'T WORK

Take a little time to think about what is and what isn't working for you. Make a list, with the pros on one side and the cons on the other. Aim for those positives!

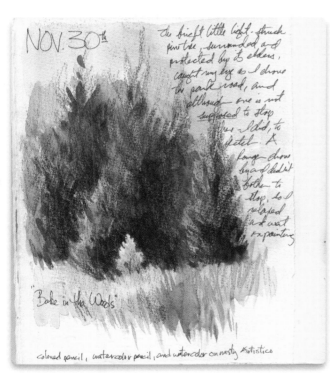

Paper That Didn't Work
Here's a sketch that just didn't work for me, no matter how I tried to rescue it. I wasn't used to the paper, and the pencil work seemed too coarse. Watercolor pencil didn't help, nor did loose watercolor washes on top. Sometimes I love watercolor pencils, sometimes not, especially if the paper isn't cooperative! This was one of those "not" times.

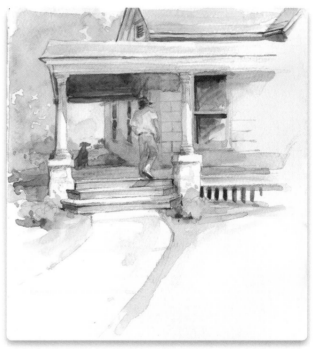

Success With the Same Paper
On the other hand, that paper was just fine for a straight watercolor. Here's my husband walking up the steps to the house we're rehabbing. The more you work, the better you'll learn what paper you prefer for which medium.

RULES DON'T APPLY

All too often someone will make a sweeping statement about what you "should" do in the pages of your journal:

"Don't erase."

"Draw in ink without any preliminary pencil sketching."

"Do something every single day, whether you feel like it or not."

"Draw big."

"Add notes to your pages."

"Don't add notes to your pages."

In the end, these are only suggestions and opinions. Whatever works best for you is what you should do. Don't let yourself feel guilty or pressured. That will suck the joy out of the enterprise faster than anything.

Sure, it's sometimes more exciting to see a line redrawn instead of erasing what you think of as a mistake. As I've said, that line makes an interesting vibration and can also help you learn. But are you happier erasing the line you don't like and having a cleaner image? Then go for it! Do what satisfies you.

Of course it's good to have daily practice, but if you just can't—if life gets in the way, if you're pressured with a dozen other things, if you flat out don't feel like it—don't beat yourself up. Tomorrow is a new day.

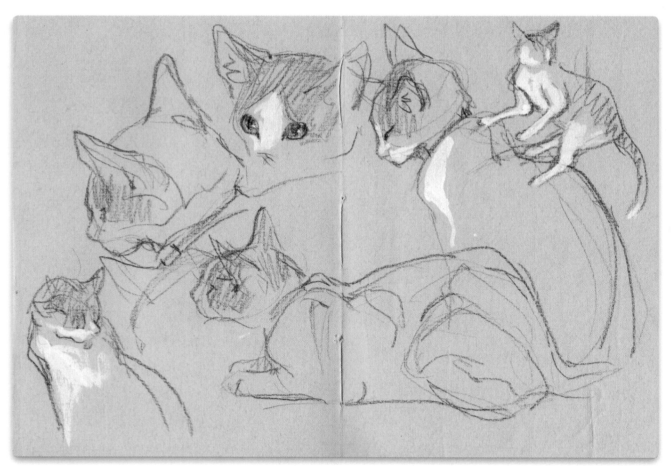

Moving Model
Sometimes your model will move—a lot. You can see that in this situation I kept adjusting my lines and shapes as the cat changed positions. It gives this spread a lively, kinetic feel.

TRY THIS

EXAMINE YOUR RULES

Sometimes you don't really think about the rules you work under or examine the "why" behind them. Try writing about that in your journal.

Does giving yourself permission to erase set you free? Does a quick pencil sketch under your ink or watercolor give you a safe feeling just from knowing that guideline is in place? Do you like the downhill-skiing excitement of jumping right in with ink? Do you delight in happy accidents, considering them doorways to discovery, or do they tick you off?

Stop and think about these things. Write down your thoughts. The more you understand what you like and why, as well as what makes you uncomfortable, the more you can tailor your journaling to become a truly satisfying experience.

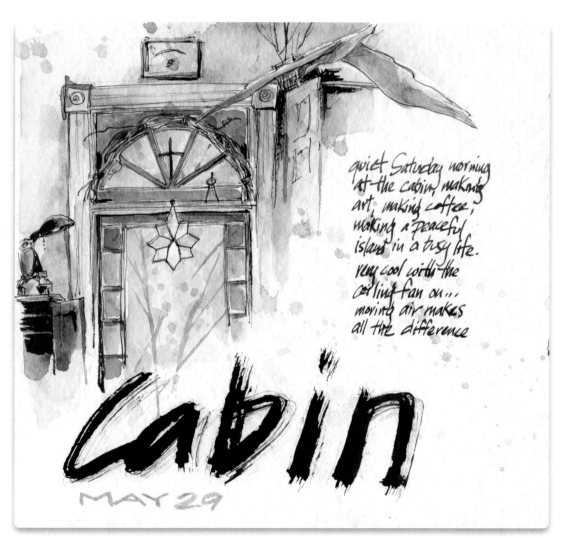

quiet Saturday morning at the cabin, making art, making coffee, making a peaceful island in a busy life. very cool with the ceiling fan on... moving air makes all the difference

Cabin

MAY 29

Satisfying Page
This page exemplifies many of the things I like to do—using ink with watercolor applied loosely on top, spending time being quiet and experimenting with new tools or materials, like the Japanese twig brush I used for the word *Cabin*.

CONTINUE TO EXPLORE

Stretch yourself from time to time. That surface is only a sheet of paper, and if you don't like what you've done, there are all kinds of ways to deal with it. It's best to leave it in your journal, though, as a reminder of a learning experience.

Take a peek at other peoples' journals. You know your own favorite approaches, but looking at what others are doing will keep you fresh and challenged. Seeing others' test pages on their Flickr or Picasa accounts can give you lots of ideas for approaches, mediums or tools you'd like to try.

If you can, spend time with other journal keepers in person; you'll be surprised at all the things that inspire you—not only their pages, but their working methods and materials and your insights into what inspires them.

Ideas Picked Up Here and There

I put together a list of ideas I've picked up along the way. Keep in mind, there are lots more ideas out there:

- When working on the spot, I often wear the cut-off cuff of an old cotton gym sock on my wrist. It's a superhandy paint rag, and when the weather's really hot, it's even rather cooling, once wet.

- A film can or small jar makes a great traveling water container. Attach it to the mixing area of your palette with a two-sided adhesive strip for stability while working.

- A cutoff drinking straw can protect your brush hairs when you travel.

- If you need a longer brush or pen, try fitting a cutoff straw on your brush handle.

- You can paint with straws as well.

- A folded paper towel or tissue fitted into the top of your traveling watercolor box keeps everything from rattling around and ensures that you always have at least one tissue handy for blotting.

- Paste an envelope in the back of your journal or on any page inside to hold ephemera that you don't want to glue in permanently. A windowed envelope from a CD works great.

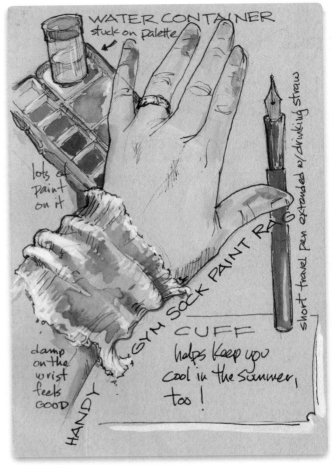

Wrist Cuff
A cuff from an old sock makes a perfect paint rag. Also note the small water container.

- If you don't like a page or part of one, glue a patch over it. Leave one side open and the patch will form an envelope or pocket to slip goodies into.

- An extra flap of paper tipped onto a journal page lets you write notes without infringing on the art. Flaps can also hide a sensitive bit or help you explore different variations or possibilities.

Ephemera Envelope
The window of a CD envelop lets you peek at the contents.

Flaps to Test Bookshelves
I wanted to explore more than one idea for bookshelves in my new studio shed. I found paper in a lighter weight than my journal page and cut it into flaps to fit the bookshelf space. Then I drew a couple of different possibilities.

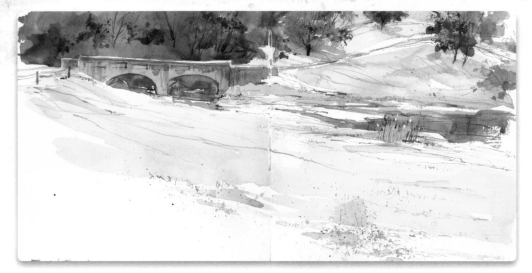

Bamboo-Skewer "Brush"
A bamboo skewer that I picked up at the grocer fits neatly in a corner of my watercolor box. The skewer made nice linear effects in the grass and rocks of this sketch.

- A bamboo skewer can be a drawing tool. Dip it into ink or a pool of watercolor. For darker lines, bruise the paper with the skewer as you draw into a wash. The bruising makes the paper more accepting of pigment. Before starting to work, you may need to soak the skewer to give it time to draw in the liquid. Not all skewers work the same. Try several—they're inexpensive.

- To reduce weight in your travel kit, hold pencils or brushes together with a rubber band instead of a bulky brush holder. This also makes brushes easy to find and even offers a bit of protection.

- Use a large elastic hair band or stout rubber band to bookmark your journal pages or keep them from flapping in the wind. (Hair bands last longer.)

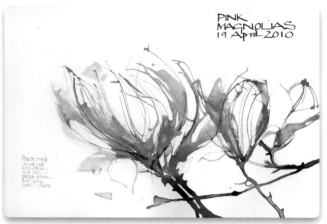

Palette Knife and Watercolor Floral
Pat Southern-Pearce used a palette knife to apply watercolor with beautiful results.

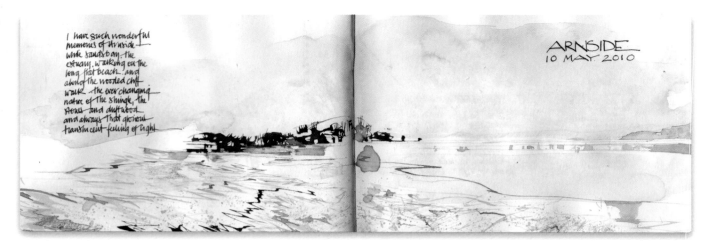

Palette Knife and Watercolor Landscape
The palette knife works beautifully on landscapes as well, as Pat Southern-Pearce demonstrates here.

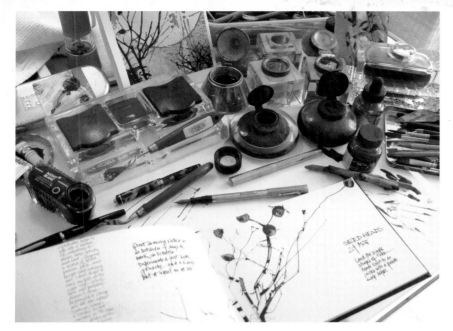

Palette Knife and Ink
You can apply ink with a palette knife. Here you see Pat Southern-Pearce's entire setup.

- Use jars or mugs to organize brushes, pens and pencils at home. An office pencil, pen and tool organizer works well, too.

- Use a palette knife for watercolor. Years ago, Zoltan Szabo suggested this surprising tool for painting linear things like branches and twigs. I've found that the knife holds the paint better when I sand the lacquer off the metal or hold the tip over a gas flame.

- Make your own small watercolor kit from a candy tin, cough drop container, makeup compact or vintage cigarette case. You can either glue in empty plastic watercolor pans or make your own pans.

- Repurpose an existing watercolor box to suit your needs. If you don't like tiny half pans, replace them with full pans or simply fill the wells with paint from a tube. Pull out removable trays to make a lighter kit and glue empty plastic paint pans in with rubber cement or a two-sided adhesive strip.

Recycled Set
Refurbish an old metal watercolor set meant for kids, as I did here. You'll enjoy the custom handcrafted approach.

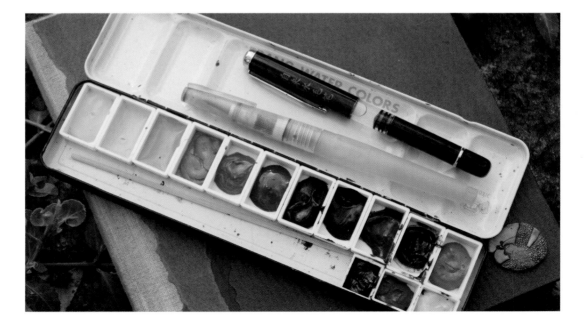

GO ONLINE

Consider joining an online art group. There are any number of group pools on Flickr (www.flickr.com), for instance, for everything from travel, nature or urban sketching to sketching supplies to journal keeping itself. I guarantee you'll find inspiration as well as many art tips.

I first discovered Enrique Flores's wonderful watercolors on Flickr. His clean, fresh travel sketches make you feel as if you're right there.

Enrique jumps right in with watercolor, no preliminary sketching. He works from large shapes to small, carefully observed and planned, which results in sure, exciting journal pages that need little text.

Take note of how different artists handle the same subject. There's no one way. My friends Maria Hodkins and Laura Frankstone both painted feathers—but what a difference!

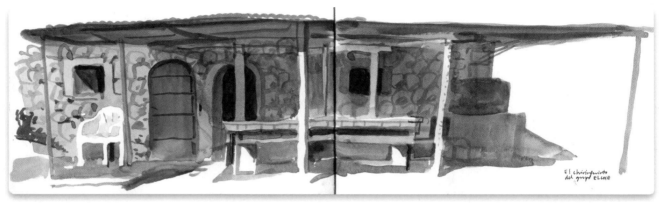

Composition and Chronology
This low stone house by Enrique Flores has just enough detail.

Sometimes I see clearly a scene I want to fix on paper. Depending on the composition chosen, I use a double or a single page. Sometimes I draw a tiny detail and leave some white space around for writing. I never rip off a page,

no matter what the quality of the drawing. I try to follow a chronological order, and I keep a calendar on the last two journal pages.

—Enrique Flores.

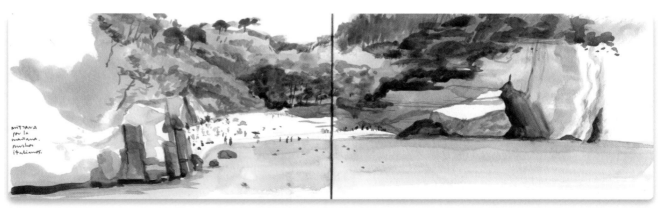

From Large to Small
Enrique Flores first painted the large shapes of cliffs, sea and beach. Then he added fine details and miniature people for scale.

Check the library and the bookstores, both online and storefront, for books on journal keeping. Some are classics that have been around a while; some are brand new. Almost all have ideas that can be integrated into your own journal keeping approach or, if you need inspiration, suggest new directions.

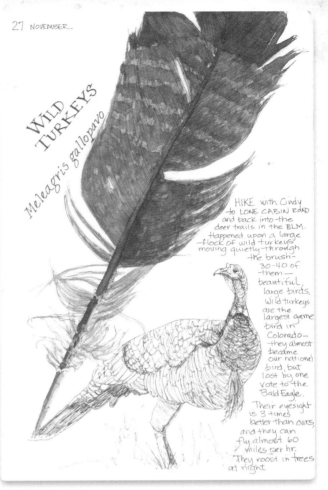

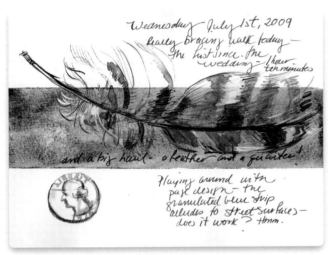

Symbolic Rendering
When Laura Frankstone created this page, she was experimenting with different page layouts, colors and textures as well as the rendering of the feather, which seems to symbolize freedom and flight.

Realistic Rendering
Maria Hodkin's turkey feather looks almost real. You have to look close to see the fine, feathery ink lines.

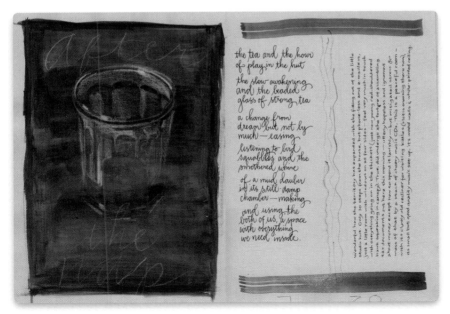

Work of a Longtime Journalist
Author-artist Hannah Hinchman worked on toned paper for this journal spread. An acrylic wash makes an interesting background on the left, and the two stripes of color on the right visually connects the two pages to each other.

FOLLOW YOUR INCLINATIONS

The same subject can work well with whatever medium or techniques you're in the mood for at the moment. At one time you may prefer ink and watercolor, using the ink to create a framework for quick washes. At other times you may prefer a slower, more formal approach, like traditional watercolor.

By now you may know which medium you want to use, according to your mood, your subject and how much time you have. That means you've learned to integrate your media and techniques into real life.

Ink and watercolor are a favorite combination for many journal keepers, and that combination of media lends itself to a wide variety of styles and interpretations.

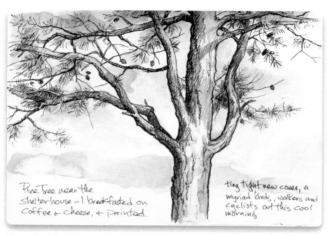

Speedy Ink
Although the ink drawing here is rather complex, it was still fairly quickly completed. Drawing is more familiar to many people than painting.

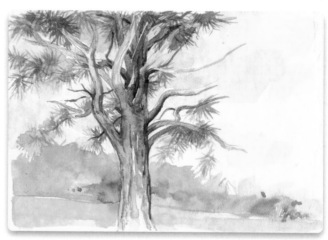

Leisurely Watercolor
I was feeling relaxed when I made this sketch, so I took the time to do a watercolor in my journal.

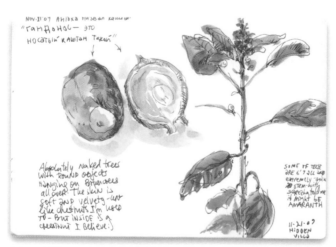

Ink and Watercolor: Fast and Loose
Nina Khashchina worked fast and loose in her daily sketch journal.

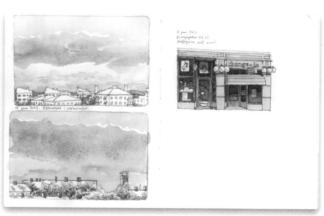

Ink and Watercolor: Controlled
Nina Johannson enjoys a more contemplative approach—with great control.

TRAVEL LIGHT

Part of the fun of traveling is planning what to take. That applies to journaling supplies, too. You may want to choose a particular medium or combination of mediums (or even a specific range of colors). Regardless, you need to simplify and lighten your load. You won't have collage materials, liquid mask or all the tools that are at your disposal at home. Choose a smaller, lighter-weight palette with fewer colors. Regular travelers have this down to an art.

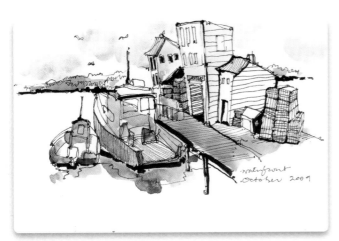

Traveler 1
Jennifer Lawson uses a combination of ink pen and brush, then adds color for an energetic effect.

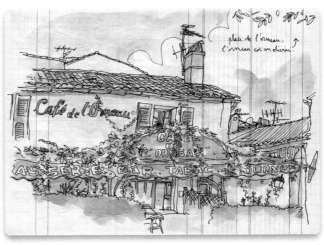

Traveler 2
Lapin's approach is to use clean lines, sometimes complex, and add loose, free washes.

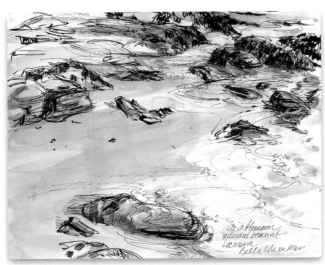

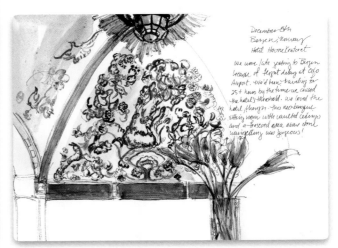

Traveler 3
Laura Frankstone used ink and watercolor for two very different subjects—the seashore and a vaulted ceiling of a hotel in Oslo, Norway.

I adjust my traveling palette according to the light and colors of the place I'm going to. I research the culture and topography and nature of the region, but I don't look much at the work of its artists. I want my reaction to a place to be as purely mine as it can be. Because I travel to places that appeal to me visually and emotionally, it's a safe bet that I'm also going to love sketching them.

—Laura Frankstone

You may discover that switching from your normal medium to more a travel friendly one works for you. And don't forget that travel sketching can be used to plan future works as well as to capture the moment. But don't feel tied to local color. Sketch your mood; sketch how the scene makes you feel; sketch with whatever you have on hand.

Media Switch
Roberta Hammer normally works in pastels, but she finds colored pencils a good substitute when travelling—lightweight and not messy.

Planning Sketch
Pencil and watercolor gives Steve Penberthy all the information he needs for future paintings, reminding him of composition, color, value and the beauty of nature.

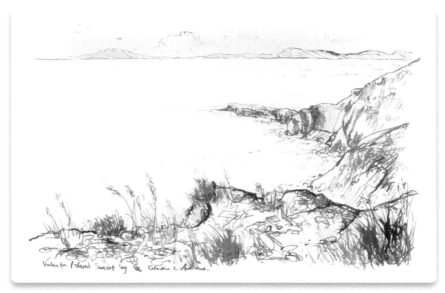

Break Free From Local Color
Catriona Andrews used gorgeous color and sweeping lines to create a much more exciting page of Valentia Island than she might have if she had stressed about matching the colors she saw in the scenery.

TRY THIS
BREAK-OUT COLOR

Choose a few colored pencils in a range of values or a handful of fiber-tipped pens and use them, no matter what, to sketch what's before you. Choose a subject that's relatively simple—a piece of fruit, a leaf, a single tree. Breaking away from local color is liberating!

DAY BY DAY

Celebrating the everyday is one of the loveliest uses of an artist's journal. You don't need to wait for the trip of a lifetime or until you're doing something you think is important enough to capture on paper. Once you begin to keep a journal regularly, you'll discover that every day truly does matter.

By now, if you've done most of the exercises and tried out a variety of approaches, exploring your own unique creative focus, you'll be well on your way to understanding the timeless appeal of journaling. As an artist and creative being, you'll have channeled your energies into celebrating life's triumphs, marking its milestones and dealing with its challenges.

Isn't that worth the time it takes?

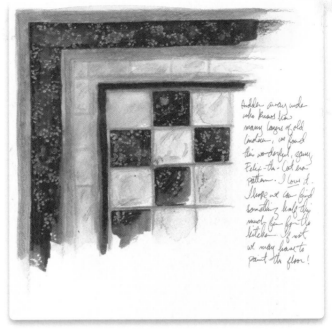

A Tile in Time
This is the vintage linoleum that was under multiple layers in the house my husband and I were rehabbing. It was torn and in bits, but I saved what I could in this sketch.

Simply Meaningful
Catriona Andrews explored her two favorite kinds of crackers on a surprisingly elegant journal page.

RESOURCES

Book Contributors

Catriona Andrews
Berwickshire, Scotland
inkling-blots.blogspot.com

Pam Johnson Brickell
Bluffton, South Carolina
www.flickr.com/photos/pjbee

Ellen Burkett
Pico Rivera, California
shesanartistshedontlookback
.blogspot.com

Fred Crowley
Springfield, Virginia
www.flickr.com/photos/54217873@N04

Alissa Duke
New South Wales, Australia
www.flickr.com/photos/alissaduke

Laure Ferlita
Brandon, Florida
www.laureferlita.com

Enrique Flores
Yucatán, Mexico
www.flickr.com/photos/4ojos

Laura Frankstone
Chapel Hill, North Carolina
laurelines.typepad.com

Danny Gregory
New York City
www.dannygregory.com

Roberta Hammer
Excelsior Springs, Missouri
www.artbyhammers.com/index.htm

Hannah Hinchman
Chico, California
picasaweb.google.com/
117724687970794400108

Maria Hodkins
Paonia, Colorado
www.windword.net

Nina Johansson
Hägersten, Sweden
www.ninajohansson.se

Nina Khashchina
Palo Alto, California
apple-pine.com

Gay Kraeger
Los Gatos, California
www.flickr.com/photos/gaykraeger

Lapin
Barcelona, Spain
lesillustrationsdelapin.com

Jennifer Lawson
Portland, Maine
jenniferlawson.blogspot.com

Steve Penberthy
Maryland Heights, Missouri
www.stevepenberthy.com

Jeanette Sclar
Overland Park, Kansas
www.flickr.com/photos/longears

Pat Southern-Pearce
Lancashire, England
www.flickr.com/photos/37479296@N06

Liz Steel
New South Wales, Australia
www.flickr.com/photos/
borrominibear

Roz Stendahl
Minneapolis, Minnesota
www.rozworks.com

Rick Tulka
Paris, France
www.flickr.com/photos/leselect

Jessica Wesolek
Santa Fe, New Mexico
www.dotcalmvillage.net

Sandy Williams
Niles, Michigan
www.soundofwings.com

Vicky Williamson
El Dorado, Kansas
www.flickr.com/photos/vickysketches

For additional information go to artists
journalworkshop.blogspot.com.

Books on Journaling

1,000 Artist Journal Pages: Personal Pages and Inspirations, Dawn DeVries Sokol (Quarry Books, 2008)

The Art of Travel With a Sketchbook: Six Tips to Get Started, Mari Le Glatin Keis (Design Originals, 2007)

The Creative License: Giving Yourself Permission to Be the Artist You Truly Are, Danny Gregory (Hyperion, 2005)

The Decorated Journal: Creating Beautifully Expressive Journal Pages, Gwen Diehn (Lark Books, 2006)

The Decorated Page: Journals, Scrapbooks & Albums Made Simply Beautiful, Gwen Diehn (Lark Books, 2003)

Everyday Matters, Danny Gregory (Hyperion, 2007)

Keeping a Nature Journal: Discover a Whole New Way of Seeing the World Around You, Clare Walker Leslie and Charles E. Roth (Storey Publishing, 2003)

An Illustrated Life: Drawing From the Private Sketchbooks of Artists, Illustrators and Designers, Danny Gregory (HOW Books, 2008)

Illustrating Nature: Right-Brain Art in a Left-Brain World, Irene Brady (Natureworks Press, 2004)

A Life in Hand: Creating the Illuminated Journal, Hannah Hinchman (Gibbs Smith, 1999)

Real Life Journals: Designing & Using Handmade Books, Gwen Diehn (Lark Books, 2010)

A Trail Through Leaves: The Journal as a Path to Place, Hannah Hinchman (W.W. Norton & Company, 1999)

Books on Sketching and Drawing
Fast Sketching Techniques: Capture the Fundamental Essence of Elusive Subjects, David Rankin (North Light Books, 2000)

Keys to Drawing, Bert Dodson (North Light Books, 1990)

Keys to Drawing With Imagination: Strategies and Exercises for Gaining Confidence and Enhancing Your Creativity, Bert Dodson (North Light Books, 2007)

The Natural Way to Draw: A Work Plan for Art Study, Kimon Nicolaides (Mariner Books, 1990)

The New Drawing on the Right Side of the Brain, Betty Edwards (Tarcher, 1999)

Painting Watercolors, Cathy Johnson (North Light Books, 1995)

The Sierra Club Guide to Painting Nature, Cathy Johnson (Sierra Club Books, 2000)
The Sierra Club Guide to Sketching in Nature, Cathy Johnson (Sierra Club Books, 1997)

Sketching and Drawing, Cathy Johnson (North Light Books, 1995)

Illustrated Journals and Diaries
America, 1585: The Complete Drawings of John White, Paul Hulton (University of North Carolina Press, 1984)

Beatrix Potter's Art, selected and introduced by Anne Stevenson Hobbs (F. Warne & Co., 1990)

Beyond the Aspen Grove, Ann Zwinger (Johnson Books, 4th edition 2002)

David Gentleman's London, David Gentleman (Antique Collectors' Club, 2010); also *David Gentleman's Paris, David Gentleman's India, David Gentleman's Britain, David Gentleman's Italy* and more

Little Things in a Big Country: An Artist & Her Dog on the Rocky Mountain Front, Hannah Hinchman (W.W. Norton & Company, 2004)

Muriel Foster's Fishing Diary, Muriel Foster (Viking Press, 1980)

New York Sketchbook, Jerome Charyn and Fabrice Moireau (St. Martin's Press, 2005); also *Paris Sketchbook, Loire Valley Sketchbook, Provence Sketchbook* and more

A Sketchbook of Birds, C.F. Charles Tunnicliffe (Holt, Rinehart and Winston, 1979)

When Wanderers Cease to Roam: A Traveler's Journal of Staying Put, Vivian Swift (Bloomsbury USA, 2008)

Instructional CDs and DVDs
10-Minute DVD Art Lesson series, John Lovett (www.johnlovett.com)

Beginning Watercolor Journaling, Gay Kraeger and Christina Lopp (www.watercolorjournaling.com)

Keeping an Artist's Journal, Cathy Johnson (www.cathyjohnson.info)

Very, Very Quick & Easy Bookbinding, Cathy Johnson (www.cathyjohnson.info)

Watercolor Journaling for the Traveling Artist, Don Getz

Classes
Irene Brady: nature journaling (www.natureworkspress.com)

Laure Ferlita: Imaginary Trips journaling classes (www.imaginarytrips.com)

Maria Hodkins: nature, visual, spiritual and travel journaling; nature sketching; book binding (www.windword.net)

Cathy Johnson: keeping an artist's journal, sketching, watercolor and more (www.cathyjohnson.info)

Pam Johnson Brickell: workshops and field trips in southeast United States (www.creatingnaturejournals.com)

Gay Kaeger and Christina Lopp: watercolor journaling (www.watercolorjournaling.com)

Roz Stendahl: journaling and bookbinding (www.rozworks.com)

Jessica Wesolek: art journaling (www.dotcalmvillage.net)

15 14 13 12 5 4

DISTRIBUTED IN CANADA BY FRASER DIRECT
100 Armstrong Avenue
Georgetown, ON, Canada L7G 5S4
Tel: (905) 877-4411

DISTRIBUTED IN THE U.K. AND EUROPE BY
F&W MEDIA INTERNATIONAL, LTD
Brunel House, Forde Close, Newton Abbot, TQ12 4PU, UK
Tel: (+44) 1626 323200, Fax: (+44) 1626 323319
E-mail: enquiries@fwmedia.com

DISTRIBUTED IN AUSTRALIA BY CAPRICORN LINK
P.O. Box 704, S. Windsor NSW, 2756 Australia
Tel: (02) 4577-3555

Edited by Holly Davis
Designed by Guy Kelly
Production coordinated by Mark Griffin

Journal Artists on Cover
Top left: Cathy Johnson
Top right: Nina Johansson
Bottom left: Danny Gregory
Bottom right: Gay Kraeger

METRIC CONVERSION CHART

To convert	to	multiply by
Inches	Centimeters	2.54
Centimeters	Inches	0.4
Feet	Centimeters	30.5
Centimeters	Feet	0.03
Yards	Meters	0.9
Meters	Yards	1.1

About the Author

Cathy Johnson has written more than thirty-five books, many on art. She has been a contributing editor, writer and illustrator for *Watercolor Artist* for over decade and has written regular columns for that magazine and *The Artist's Magazine*. She started the popular group blog Sketching in Nature (naturesketchers.blogspot.com). She also teaches online workshops at www.cathyjohnson.info and runs the blogs The Quicksilver Workaholic (katequicksilvr.livejournal.com) and Cathy Johnson Fine Art Galleries (cathyjohnsonart.blogspot.com). Her blog Artist's Journal Workshop (artistsjournalworkshop.blogspot.com) expands on topics and contributors featured in this book. Johnson lives and works in Excelsior Springs, Missouri, with her husband and cats.

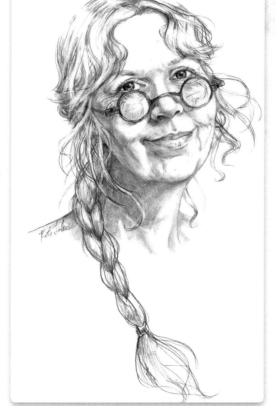

Dedication

To my Joseph, who has changed my life for the better in more ways than I can count.

Acknowledgments

People sometimes imagine a writer locked away somewhere slaving away at the computer, a solitary figure who creates a book from start to finish. Of course nothing is farther from the truth. A book—virtually *any* book—is more like a concert than a solo. From the germ of the idea to this finished book you hold in your hands, many people have played a part. To all of those, I owe my thanks.

To my wonderful students, who have offered ideas and asked all the right questions; to my editor, Holly Davis, whose encouragement and calm guidance have been a delight to work with; to Pam Wissman, editorial director and acquisitions editor at North Light Books, who's been a good friend forever—thank you. To Kelly Messerly, with whom I've worked on lots of ideas and projects and who guided this book through idea to acceptance for publication, and to Suzanne Lucas, who helped tie everything into a neat package, my heartfelt thanks.

To the Authors Guild, your support and guidance over the past twenty-plus years have been invaluable!

To the incredible artists and journal keepers from all over the world who have agreed to share their work in this book, I am humbled and delighted to offer you thanks. From my dear friend Laura Frankstone to my oldest friend, Roberta Hammer—including Catriona Andrews, Pam Johnson Brickell, Ellen Burkett, Fred Crowley, Alissa Duke, Laure Ferlita, Enrique Flores, Danny Gregory, Hannah Hinchman, Maria Hodkins, Nina Johansson, Nina Khashchina, Gay Kraeger, Lapin, Jennifer Lawson, Steve Penberthy, Jeanette Sclar, Pat Southern-Pearce, Liz Steel, Roz Stendahl, Rick Tulka, Jessica Wesolek, Sandy Williams, and Vicky Williamson—I thank you all! You inspired me, and I know you will inspire the readers of this book, which is truly a group effort.

And last but never least, to my wonderful, supportive knight, my husband, Joseph Ruckman, who kept me fed, made sure I got enough rest, carried my bags through airports, helped bind books and contact artists and shared my everyday life between book crazies—thanks, babe!

INDEX

IDEAS. INSTRUCTION. INSPIRATION.